DRAWN ON THE WAY

A GUIDE TO CAPTURING THE MOMENT THROUGH LIVE SKETCHING

SARAH NISBETT

QUARRY

Brimming with creative inspiration, how-to projects, and useful information to enrich your everyday life, Quarto Knows is a favorite destination for those pursuing their interests and passions. Visit our site and dig deeper with our books into your area of interest: Quarto Creates, Quarto Cooks, Quarto Homes, Quarto Lives, Quarto Drives, Quarto Explores, Quarto Gifts, or Quarto Kids.

First Published in 2021 by Quarry Books,
an imprint of The Quarto Group,
100 Cummings Center, Suite 265-D, Beverly, MA 01915, USA.
T (978) 282-9590 F (978) 283-2742 QuartoKnows.com

Quarry Books titles are also available at discount for retail, wholesale, promotional, and bulk purchase. For details, contact the Special Sales Manager by email at specialsales@quarto.com or by mail at The Quarto Group, Attn: Special Sales Manager, 100 Cummings Center, Suite 265-D, Beverly, MA 01915, USA.

10 9 8 7 6 5 4 3 2 1

ISBN: 978-0-76037-072-8

Digital edition published in 2021
eISBN: 978-0-76037-073-5

Library of Congress Cataloging-in-Publication Data is available.

Design: Debbie Berne Design
Cover Images: Sarah Nisbett
Page Layout: Debbie Berne Design
Photography: Sarah Nisbett, except Hadley Whittemore, pages 4, 32, 73, 76, 118 (right), 121 (bottom left), and 127; and Eian Kantor, page 7
Illustration: Sarah Nisbett

Printed in China

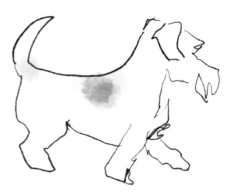

FOR MATTY,
MY BESTEST BROTHER, FRIEND, AND TEACHER

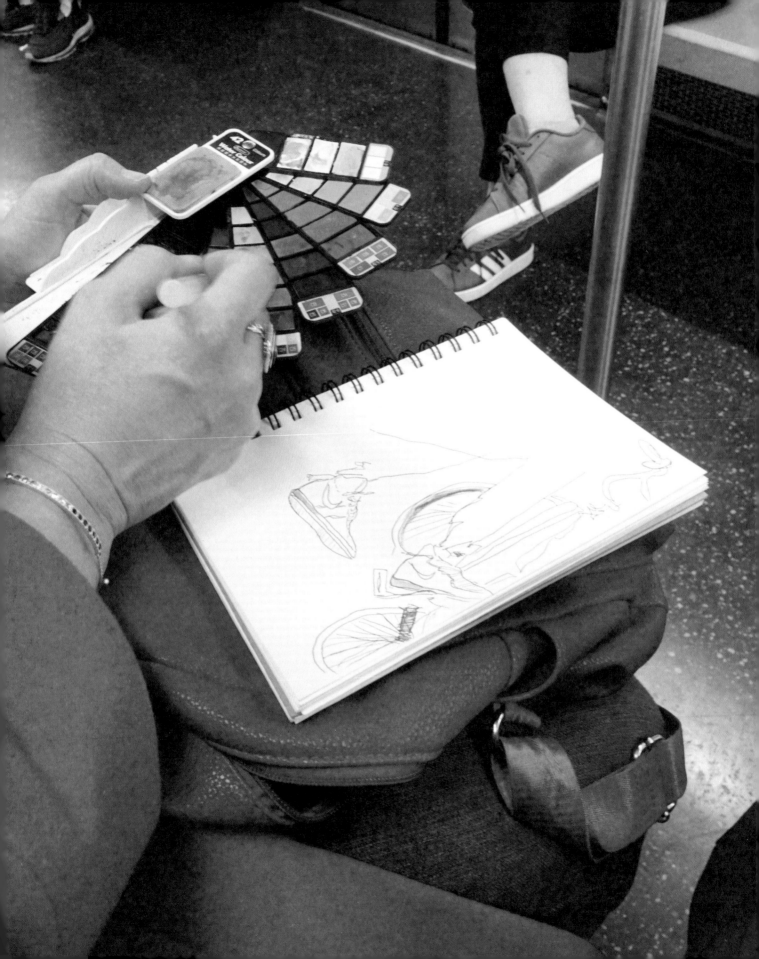

CONTENTS

INTRODUCTION

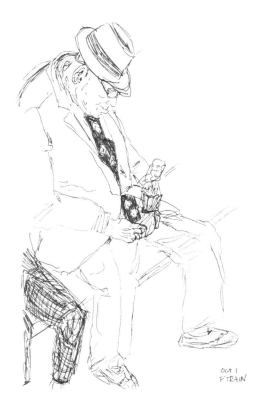

Oct 1
F-TRAIN

This book is about telling stories with drawings, so it's only fitting that it begins with the story of how I became an artist.

I accidentally started what would become my Drawn on the Way project while commuting in New York City on the F train one evening in 2012. I am not a trained artist; in fact, I'd never even tried to sketch anyone before. But, tired of staring at a screen, I took out the blank notepad I had stashed in my purse and a pen stolen from the office supply closet at work and looked up for inspiration.

An older gentleman in a rumpled three-piece suit and matching fedora caught my eye and I sketched him, not knowing that in the midst of my evening commute, I had started what would become a daily live-sketch project that would generate thousands of sketches and introduce me to people from all over the world. I began sharing my daily drawings, first by giving them to the people who inspired them, then by letting fellow commuters watch over my shoulder, and finally by sharing them on social media. I marveled at the way these moments, captured quickly in my sketchbooks, could create community and connection, and it inspired me to keep drawing and to keep tuning in to these often-overlooked on-the-way moments.

The subway may seem like an unlikely place to go to art school, but it was there I found my best teachers: time, repetition, and mistakes. Together they taught me everything I needed to know about drawing from life and doing it in my own style.

I only had a little time, a little sketchbook, a bumpy subway ride, and a simple pen to describe what I saw on the way. Because I didn't let that hold me back, I discovered my own way of doing it—my own approach.

As a self-taught artist, I didn't want to write a book full of rules that would erase all the wonderful, creative ideas sitting in your head right now, just waiting to get out.

This is more than a book about how to draw. This is a book about how to see: how to see the world differently, as a place filled with stories; how to see the people around you differently, as works of art; and how to see yourself differently, as someone whose voice has a place, even if it's just in the private pages of your own sketchbook.

This book is a warm invitation to engage your own creativity, using simple supplies and a universal and ever-present source of inspiration: the world. This book will not teach you how to draw like me; rather, it will guide you through the process of drawing from life in your own style.

This is a book about drawing, but it's also a book about living.

I hope this book makes you curious about your world and your place in it. Curiosity, empathy, joy, and wonder are foundational to the techniques explained here. And just like the materials you'll use to make your drawings, you can carry this worldview with you everywhere.

THE CONSTRAINTS OF SIMPLICITY
INSPIRE CREATIVITY

CHAPTER 1

TOOLS AND MATERIALS

Although I believe there are very few hard-and-fast rules for creating art in your own unique style, I have found that a nonnegotiable requirement for drawing is having something to make marks with and something to make those marks on.

In this chapter, we'll review the basic materials we need for *drawing on the way*. We'll also learn about the importance of choosing the right tools based on what they can do for us—and what they can teach us.

Keeping It Simple

While there are many technical reasons to choose a particular pen or type of paper, let's talk about the less obvious reasons why the materials you choose are important to the art you make.

For nearly a decade now, I've made portraits with just an ordinary office pen, and it's been more than enough. I suggest that you keep it simple at first, and focus on using only a pen for your on-the-way drawings. Using one basic tool removes the anxiety that comes with having too much creative choice. The constraint of having one tool to generate shapes, colors, textures, and patterns will force you to be innovative and to explore.

There is another reason for using a pen: Where we're going, you won't need erasers. A huge part of the joy and purpose you'll find in drawing from life is how it connects you to your creative self. An eraser interrupts that connection because it suggests that there is a right and wrong to what you are doing—and this is simply not true.

Drawing without an eraser, you'll tap into your instincts. And I promise you that you *do* have creative instincts, because all humans do.

Without an eraser, each line becomes an act of bravery. You'll see the full record of your artistic process. The lines that don't communicate what you want will sit right next to the ones that do. Each line becomes a lesson, a teacher in its own right. Don't allow your fear of making mistakes to rob you of this education. There will be a time for erasers, but now is not that time. Now is the time to allow yourself to exist unfiltered on the page.

LIVING YOUR LIFE IN INK
Without an eraser, there is no going back. When it comes to the work at hand, there are only three choices: Accept what you've made as good and move on; turn the page and start over; or work with your mistakes and turn them into something you like. These are the constraints of working in pen, but they mirror the choices we have at any given moment in life. So let's leave our erasers behind and boldly begin.

The Basics

You don't need fancy supplies to make great art. Use what's on hand and try a few options. Once you find something you like, stick with it for a while and get to know it before trying something new.

PENS

Here are a few of my favorite pens, with some pros and cons for each.

Rollerball Pens

A rollerball pen has a rolling ball at the tip of the pen that is inked by a reservoir above it. This is my preferred type of pen. Every drawing in this book was made with the uni-ball Roller pen in blue with a 0.7 mm point.

WHAT'S NICE ABOUT THEM:

- Smooth ink flow (similar to a fountain pen)

- Vibrant color

- Pressure sensitive; easily makes lighter or darker marks

- The water-resistant ink means you can add watercolor over it without smudging. It's also fadeproof (important, because, let's assume you're a genius who wants your work to last forever).

THINGS TO LOOK OUT FOR:

- Though it's a fast drying ink, smudges may still occasionally occur. Using a slightly textured paper can help avoid this.

Ballpoint Pens

Ballpoint pens work like rollerball pens, but a ballpoint pen has thicker, oil-based ink.

WHAT'S NICE ABOUT THEM:

- Lasts a long time

- Can be found at the bottom of any purse, backpack, or car seat if you dig around long enough

THINGS TO LOOK OUT FOR:

- Because the ink is more viscous than rollerball ink, it can accumulate around the writing tip and deposit the occasional blob of ink, which could smudge or get on your hands or clothes.

Markers and Felt-Tip Pens

Sakura Pigma Micron pens, felt-tip markers, or Sharpies are examples of this type of pen. They work by way of *capillary action,* which is the ability of liquids to flow into narrow spaces, even if gravity is not the force moving them along. When you place the tip of the marker onto a piece of paper, the paper fibers draw the ink out of the tip as you pull the pen across the page. The free-flowing nature of the ink allow these pens to produce smooth, bold, and consistent lines.

WHAT'S NICE ABOUT THEM:

- Smooth drawing

- Fast drying

- Rich color

THINGS TO LOOK OUT FOR:

- These pens can feather on some types of paper, making lines appear thicker or fuzzier. Using smoother paper helps control this.

- They can bleed through paper and possibly onto the surface below. A thicker paper helps with this.

- They can dry out quickly and always need to be stored with the cap on.

Fountain Pens

Fountain pens also work by capillary action. Pull the fountain pen toward you when drawing, since pushing it away can damage the nib or cause the ink to flow too quickly, leaving behind blotches of ink.

WHAT'S NICE ABOUT THEM:

- The fluid, water-based liquid ink offers more variation and control of line weight and thickness.

- The same fountain pen can be refilled with a rainbow of inks, so you can experiment with color.

- Over time, a fountain pen nib will mold to your writing style. If you take care of it, you can have a custom pen for life.

THINGS TO LOOK OUT FOR:

- Fountain pen inks can vary in thickness, or viscosity, and are described as either a *wet* or *dry* ink. The wetter, or thinner, ink dries much slower than the drier, or thicker, ink, and if you are not careful, your drawings can smudge before the ink has thoroughly dried.

- Be careful not to apply too much pressure, which can bend the nib and ruin your pen.

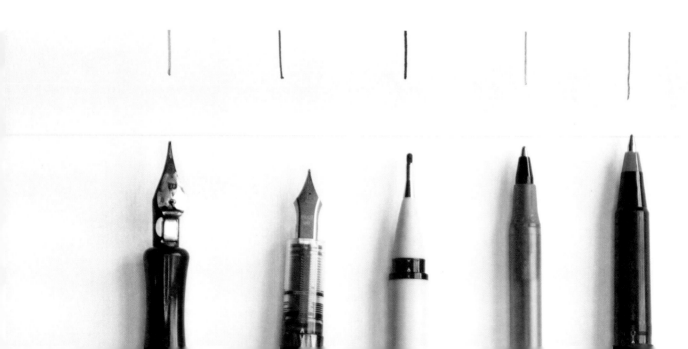

Dip Pens

A dip pen also works with capillary action, but unlike a fountain pen, it has no internal ink reservoir. To add ink to the pen, dip the nib into an inkpot, a paint palette, or small ceramic dish filled with ink. Eventually the ink will run out, and you'll need to dip again to keep drawing. Use this to your advantage, as a heavily inked pen makes a different quality line than a lightly inked pen.

WHAT'S NICE ABOUT THEM:

- A kaleidoscope of ink colors and types awaits you: waterproof ink, India ink, drawing ink, and acrylic inks. You can even custom mix inks. I like Dr. Ph. Martin's Hydrus Fine Art Watercolor inks, Winsor & Newton inks, and Quink ink from Parker.

- Dip pens are more sensitive to variations of pressure and speed, creating a line that naturally varies in thickness.

- You can swap out the nibs. I like using a *cartooning* nib that has a snub nose, makes a slightly thicker line, and easily draws in all directions.

THINGS TO LOOK OUT FOR:

- Dip pens are best for using at home.

- As with fountain pens, depending on the viscosity of the ink used, your drawings can easily be smudged.

- If you load the pen nib with too much ink, you'll end up with ink drips and blobs. Avoid this by lightly tapping the nib on the edge of the ink container to get rid of excess ink.

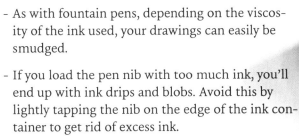
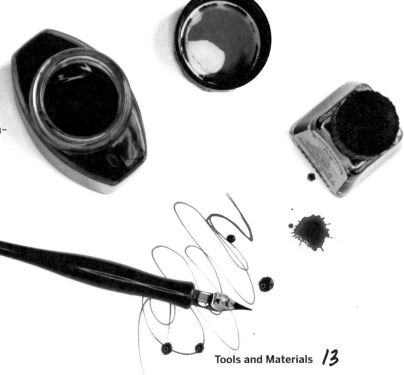

SKETCHBOOKS

Here are the three criteria I take into account when choosing a sketchbook:

Size

Pick a size that's portable. I use a Canson 5½ × 8½ inch (14 × 20.5 cm) sketchbook that fits into a backpack or purse and isn't too cumbersome to hold whether I'm standing or sitting to draw.

Larger sketchbooks can be intimidating because you might feel the need to fill the entire space. For working on-the-go, stick with something 8 × 10 inches (20.5 × 25.5 cm) or smaller.

Binding

I prefer a spiral-bound sketchbook because it opens completely flat. The binding is durable and provides a handy spot to stow your pen. The perforated pages are easy to tear out if I want to share my drawings.

Paper Type

Do you want smooth, textured, or heavyweight paper? Try out a few different sketchbooks until you find what feels good to you.

I prefer slightly textured paper because it gives me a little bit of resistance that makes me feel more connected to the page. Neutral white paper provides a nice contrast to my blue ink. I like a heavier weight paper that's less likely to bend or tear. I use a Canson Mix Media paper pad, which has heavier paper (138 lb or 224 gsm) that's suitable for wet and dry media.

PENCILS

I prefer pens to pencils because they are permanent by design. Pencils can tempt you into timidity because, in the back of your mind, you know that if you want to erase something, you can. If you still prefer using a pencil, I strongly encourage you to choose one without an eraser.

Pencils come in a variety of thicknesses, colors, and intensities and are made of different materials (generally graphite mixed with clay or wax) that can make them hard and thin or soft and smudgy. Pick up a few different types and see what appeals to you.

THE COMFORT ZONE
Your sketchbook doesn't need to be fancy, just a place you feel comfortable working in.

Expensive, high-grade sketchpads can make the blank page feel too precious. When I first began drawing, I used Canson's drawing-weight paper (Canson Universal Sketch, 65 lb [96 g] in natural white), which is smooth, thin, and inexpensive.

AND FINALLY...TIME

Finding the time to use your pen and paper can be a surprisingly challenging hurdle. Here are a few things to keep in mind about this most intangible supply:

- You can do a lot in a short amount of time. Most of my drawings take fewer than five minutes to complete (that's also the average amount of time between subway stops). You can improve your skills in a few minutes a day and more importantly, give yourself a creative break. Always carry your sketchbook and pen so you're ready to draw any time inspiration strikes.

- Make drawing part of your daily routine by attaching it to something you already do. Drawing on my morning commute became a part of my routine and something I could count on. Use your time in the coffee line to draw scenes in your local café. Keep your sketchbook handy when you're watching the kids' soccer games or walking the dog. I know someone who draws their dish rack at the end of every night.

I think of my daily drawing time as my escape from the world, which I achieve by diving deeper into it. I hope you'll enjoy whatever time you find to draw on your way, throughout the day, week, or month.

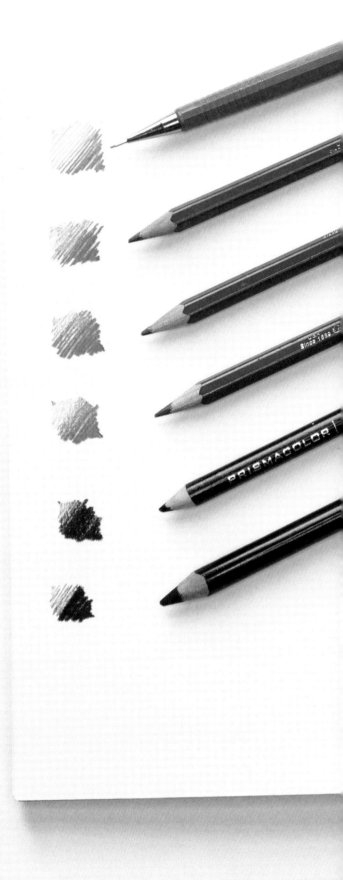

IF YOU CAN DO THE VERB, YOU CAN CLAIM THE NOUN.
IF YOU CAN MAKE ART, YOU'RE AN ARTIST.

GETTING STARTED

As a self-taught artist whose career began accidentally on an otherwise unremarkable subway ride, I consider myself a bit of an expert on the matter of beginnings.

It's a cliché, but starting is the hardest part of any new endeavor. There can be a surprisingly long distance between having a sketchbook and drawing in it. So instead of going straight from talking about supplies to how to use them, I thought we should take an important detour and talk about how to start getting started.

Start with the Right Mindset

I don't know how. I'm not good at it. We find lots of reasons to stop ourselves before we ever get a chance to start. But if you start with assumption that you have talent, there is every reason to begin. Your point of view, your heart, your mind, your ideas—those are the talent. Once you understand this, you won't confuse your current ability level with your inherent talent. If you keep seeking to express yourself, your talent will manifest as skill.

Sure, you're not Picasso. But then again, maybe you are.
After a few weeks of drawing on the subway, I was hooked. I would step on the train, reach for my sketchbook, uncap my pen, and let my eyes wander over the crowd. It was my favorite part of the day.

But things soon changed from pure joy to a mix of emotions. I loved how I felt while drawing, but when I stopped to look at what I had drawn, I didn't feel so great. I thought the only worthwhile way to re-create the world was to do it with perfect fidelity, and I was disappointed in my wobbly lines and scratchy sketches.

One day I had an epiphany, which prompted me to say to myself: You were an art history major, right? So, you know art isn't about perfectly re-creating what you see. We celebrate Da Vinci, Picasso, and Van Gogh because they re-created the world as they saw it. If you do the same, aren't you following in the footsteps of the greatest artists?

From that moment on, I decided that maybe I *was* the next Picasso. Instead of stopping, I started focusing on expressing a view of the world as I saw it. Draw what you see and feel, and your own style will naturally develop.

You might not be the next Picasso (or maybe you are!), but what's the worst that could happen if you treat your efforts—and yourself—as if you are?

Silence Your Inner Critic

Now that I've convinced you to bring yourself fully into your creative endeavors, we should talk about the uninvited guest who will tag along: your inner critic. This is the voice that tells you to stop having fun and that everything you do is dumb, or bad, or not good enough. That inner critic can be cruel and callous.

Although I'd decided I might be Picasso, my inner critic was not convinced. It would say, "You're so bad at this! OMG, that doesn't even look like the person you're drawing!" Instead of giving in to its taunts, I made a vow that when my inner critic acted up, I would talk to it like a naughty child, and simply tell it: "If you can't behave, then we can't draw today. I'm going to close the sketchbook, and you'll have to find something else to do."

I suggest you do this when that voice gets too loud. Kindly tell it to zip it. If that doesn't work, perhaps agree that today is not a good day to push. Your creativity is a precious thing. Don't let anyone, let alone yourself, contaminate the joy it can bring. There's always tomorrow to try again, and again, and again.

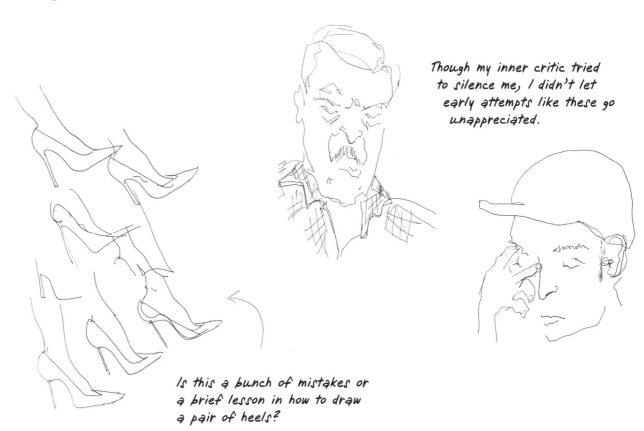

Though my inner critic tried to silence me, I didn't let early attempts like these go unappreciated.

Is this a bunch of mistakes or a brief lesson in how to draw a pair of heels?

Embrace Your Mistakes

Don't worry about what will happen if you make mistakes—plan on making them. I've certainly made plenty of my own. Your mistakes are opportunities for discovery and innovation.

I'm on the C train in New York City and she is sitting across from me on a crowded morning train. Her hair is cut into a sleek bob that frames her face with angular precision. Though only half-awake, I have managed to capture this elegance in a few simple lines. I look at my drawing; just one more line and it will be perfect. I touch my pen to the page and then watch as it suddenly veers off course, leaving a jagged trail of ink in its wake.

I have been bumped.

The woman next to me, in settling into her seat, bumped my arm and ruined what I have appraised to be the single greatest drawing I have ever made in my life, or at least this week. I want to cry.

I don't have time to start over, and I don't want to. How can I fix this? I take my pen and place it on that jagged, imperfect line and follow its path; and then I draw another line, just like it; and then another and another, until instead of a single, elegant stroke, there is an eclectic tangle of little lines defining my muse's perfect coif. I had a different drawing than I had planned, but one that I liked much better.

I started using this technique to draw hair whenever I could and looked for any opportunity to draw patterns and stripes with lines that took their own imperfect route across the page. Don't worry about what will happen if you make mistakes—plan on making them. I've certainly made plenty. Your mistakes are opportunities for discovery and innovation. Don't scratch or tear out the drawings that don't work. Let them exist as a record of your progress—a series of lessons in the form of mistakes. The more you fail, the more you'll realize that mistakes are instructional, not fatal.

Follow the Joy

My first career was as a professional opera singer. When I told people what I did, the most common response was, "Oh, I can't sing at all!" To which I would reply, "If you are physically capable of making sound, then you can sing. How good you are doesn't matter, if you're enjoying yourself."

It's important to uncouple the product from the process and redefine what good art is. Making art feels good, so enjoy it. The process of turning your world into art has some real benefits.

- It's meditative. When you draw from life, you stitch yourself into a moment in time and become deeply connected with the now, a safe place to be.

- It's recreational. Drawing from life, you re-create the world in a way that makes sense to you. When you make art about the world, you make the world yours.

It's okay to be impressed with yourself. In fact, it's important. Shift to a mindset of wonder: appreciate what you're doing and evaluate your work by joy, not excellence.

Does it make you happy? Ask yourself that question instead of, "Is it good?" Even if you don't love the final product, if you enjoy the process of its creation, you won't walk away empty handed.

I love this little seagull hunting at the shore. It may be a little rough, but when I see it, I remember that lovely day at the beach.

Becoming a Visual Storyteller

The joy of observational drawing is that it transforms everyday moments into something more. A walk through the park, a trip to the bank, or sitting in your house become something worth remembering and worth documenting. But, this transformation doesn't happen unless you learn to see the stories hidden in plain sight.

When I first began drawing from life, I thought I was just drawing the things that caught my eye. But I soon realized that I was doing more than that—I was telling a story.

As a visual storyteller, sometimes you'll know the story—like when you draw your favorite mug—and sometimes you'll have to imagine it, like drawing the stranger sitting next to you at lunch.

Find the Extraordinary in the Everyday

There are a million stories being told in any given moment. Your job is to listen with your eyes and tell those stories using lines of ink.

Curiosity is key to finding and telling good stories. Curiosity breeds empathy, and empathy is how we imagine the lives and stories happening outside of our own.

Overlook the obvious and bring the background into the foreground: the cactus that's moved with you to every new home or the barista at your local coffee shop—these are stories waiting to be told.

Look for small details that suggest a bigger story. In writing, this is called *synecdoche*, when a part is used to represent the whole, like calling a businessman a *suit*. This concept works just as well when you're drawing.

Notice how your emotions affect the stories and details you're drawn to. When you're feeling sad, you might draw the tree outside your window because of the way its branches droop. On a happier day, you might draw the same tree, focusing instead on the cheerful squirrel resting in those same branches.

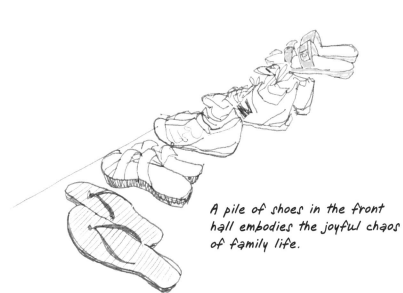

A pile of shoes in the front hall embodies the joyful chaos of family life.

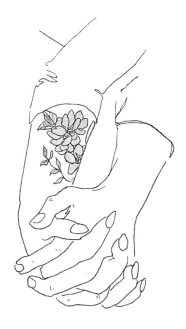

A couple's clasped hands tell an entire love story.

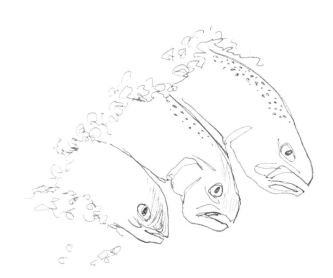

A few fish could represent a busy fish market.

Funky socks paired with fancy oxfords could speak to a high-powered "suit" with a sense of humor.

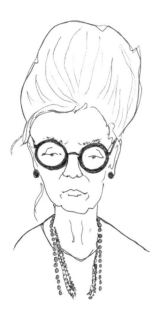

Visual Storytelling in Action

Iris, as I like to call her, is one of my favorite people I've never met. I saw her one night, sitting in a French café on the Upper East Side. She was eating alone at a table for two, facing into the restaurant so she could watch the comings and goings of waiters and patrons alike. We briefly locked eyes as I scanned the restaurant. I, too, was dining alone, and instead of catching my own reflection in the mirrored wall, I saw Iris seated across from me.

She was striking: gray hair piled high on top of her head and giant glasses taking up most of her delicate and slightly dour face. At first glance, she could have been dismissed as a sort of sad and perhaps lonely woman, but upon closer inspection, there was a tiny curl at the edge of her lips, a secret satisfied smile. I noticed the collection of beaded necklaces strung around her neck and wondered if she had collected them on exotic travels to visit faraway lovers. A few wisps of hair escaped from her careful updo. I imagined her swiping at them distractedly as she cooed to pastel colored parakeets that surely lived with her in a giant apartment filled with art, books, and secrets.

Everyone who sees my drawing of Iris has a strong response to her. I tried to capture the details about her, both obvious and subtle, that communicate who she is—or who she might be.

Sometimes a story is as simple as sharing a feeling, and your drawing becomes a short story where the viewer reads between the lines to find the meaning.

It was late spring, and New York City blooms like a flower. Apartment windows are thrown open like blossoming buds and spring wardrobes are paraded on the streets. Ankles are exposed for the first time in months, and sturdy boots are replaced with kitten heels and stilettos.

On a particularly beautiful evening, I met up with a friend for dinner outside and I noticed the woman next to me. She was sitting on a high bar stool, her legs crossed at the knees and a leopard print slingback shoe balanced precariously on the end of her toe. Above the table, she had one hand wrapped around a wine glass and the other one tucked under her chin as she leaned closer to her date. The moment was both precarious and sure, relaxed and engaged—a joyful, frivolous, flirtatious shoe that might drop at any moment.

I could have drawn the whole scene, but the sensation of it was totally expressed by the casual way she crossed her legs and her stylish, playful shoes. I know that each viewer will see this drawing differently, but I think they'll find something familiar in what this small detail evokes.

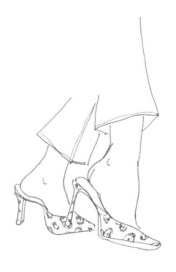

One Drawing, Three Stories

Each of your drawings contains three stories: your story, the story created by the viewer, and the story of the subject. A perfect example is this drawing of a fashionable lady zipping along on a scooter, made while I was on vacation in Paris.

My Story: This is my memory of sitting in a café, sipping cappuccinos and eating croissants, and watching Paris pass by. This chic woman, with her tiny purse, tall heels, and fancy dress, was quintessentially Parisian and a distillation of my experience in that moment.

The Viewer's Story: Because I didn't draw the details of the city street, the viewer might imagine another story altogether. Perhaps it's about the most fashionable person in Paris, Idaho. Perhaps it's about themselves riding down the street, feeling the wind and the sun.

The Story of your Subject: There is the real story of this Parisian woman, which we may never know, but upon which we can expand and imagine forever.

These three stories form an important relationship with you at the center. The drawings you make become the stories you tell about your own world. No one else can do that better than you.

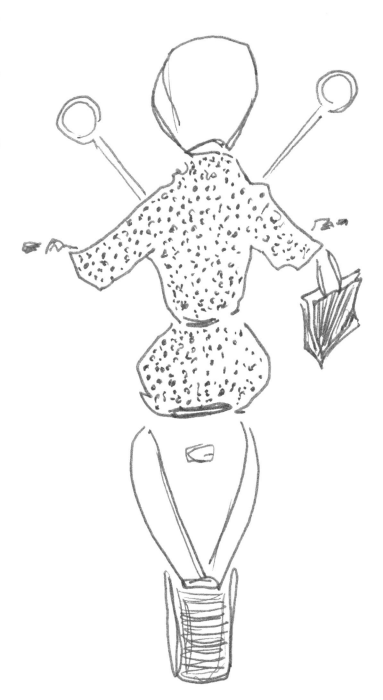

LET YOUR HEAD FOLLOW YOUR HAND,
AND LET YOUR HAND
FOLLOW YOUR HEART.

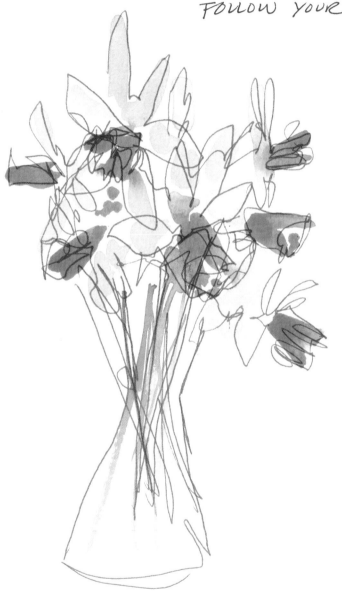

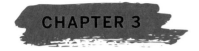
CHAPTER 3

WARM-UP EXERCISES

Now that you've accepted your job as a visual storyteller, it's time to get to work!

This new job and the process of observational drawing can be intimidating, so your first assignment is easy: drawing something without looking at the page—not even once.

It sounds scary, but don't worry. I'll be here to walk you through it.

In this chapter, we'll talk about overcoming the fear of the blank page using what I call *the hook*. And, we'll learn how to connect what you see in the real world to what you draw on the page using simple techniques, such as contour drawing, to make this process easier and more predictable.

So, turn that page and let's get started.

How to Look
Selecting Your Subjects and
Connecting Artistically with the World

I hope that you've started to see that no matter where you find yourself, you are surrounded by stories.

Even if you're just sitting at home, there's your favorite mug that reminds you of the crazy road trip pit stop. There's your dog, wagging his tail, hoping for a pat. The smallest, silliest stories and the biggest, most important ones are waiting for you to notice them.

We'll do more than notice them—we'll observe them, taking in their details and significance. As we begin to connect artistically with our world, we'll use contour drawing to assist in this deeper observation process.

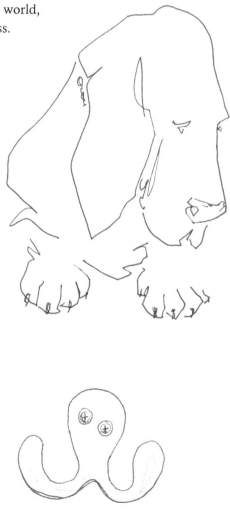

Contour Drawing and Blind Contour Drawing

Contour Drawing

A contour drawing outlines the shape, or contours, of an object. You don't add color, shading, or minute details; instead, you simply draw the object's general exterior shape as well as a few suggestive interior details.

Did you ever make an outline tracing of your own hand? This is essentially the same process for making a contour drawing. But, instead of running a pen alongside each finger and around your palm, you trace that path with your eyes, using your pen to map the course. If you want to get fancy, you can add a few interior contours, such as the details of the edges of your nails, the folds of the skin at your knuckles, or the contours of tendons or veins.

Contour drawings may look simple, but the skills required to make these drawings are the foundation of almost every artistic discipline. That's because to make a contour drawing, you practice turning observation into art and connecting your hand to your eye.

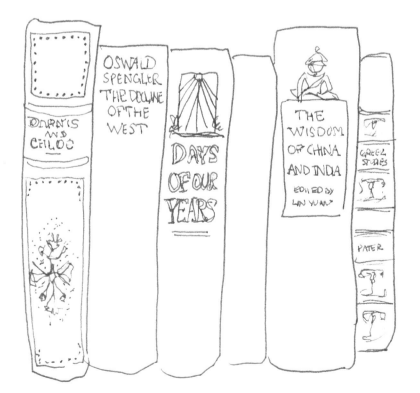

This contour drawing of a row of books is essentially a series of rectangles. The titles are fun interior details to add once the basic exterior contours have been drawn.

Contour drawing is also a great technique for drawing on the go because it's a great way to quickly re-create an object, getting the overall gist along with pertinent details. Once you have these lines on the page, you can build upon them as you see fit.

In this drawing of a horse sculpture, made in just a few minutes at New York's Metropolitan Museum of Art, the horse's outer shape is recorded as are a few details of the inner contours: the nostrils, the eye, and the ridges of the muscles and tendons.

This is a simple contour drawing of a paintbrush.

When contour drawing, pay attention to areas with big topography changes or deep shadows, since you may want to define those areas in the drawing. You can add more or fewer of these kinds of details, but overall, contour drawing is meant to be simple and uncomplicated.

Blind Contour Drawing

A blind contour drawing is a contour drawing that's made without looking at the page.

Although this may seem difficult, by drawing blind, we follow our observational instincts and bypass the critical control center of the mind. Judgment is the greatest impediment to making art, and without the ability to look at our work as we make it, we can't judge it. Blind contour drawings teach us how to focus on the process of creation, rather than on the end result.

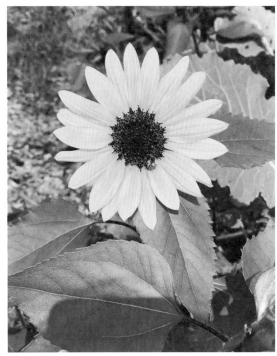

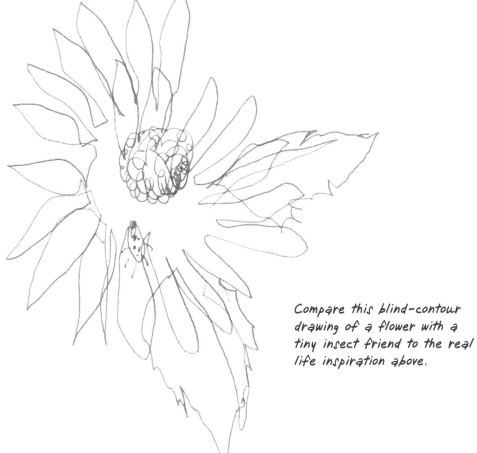

Compare this blind-contour drawing of a flower with a tiny insect friend to the real life inspiration above.

Exercises: Blind Contour Drawings

For these exercises, you'll create three blind contour drawings. Each will be done within a specific time limit: five minutes, three minutes, and one minute. Let's begin!

EXERCISE 1
Blind Contour Drawing in Five Minutes

Use a pen for this exercise. This reminds us to embrace our mistakes and that drawing is fun and we'll never take it too seriously. Even the strangest drawing has artistic value and tells a story about what you see. Here are a couple of notes before you get started:

- Try drawing in one continuous line, picking up your pen only occasionally to jump to a new area or add interior details. This orients your hand on the page by giving you a sense of where you are relative to what you've already drawn.

- Work section by section, using your line to connect to each new area of your drawing. This approach is especially helpful as you add the interior details to your object.

Think of this exercise as an artistic trust fall; your instincts catch you, and your heart and hand guide you safely around the page.

1. Since I'm not there to make sure you don't look at your paper as you draw, make an anti-peek Shield of Creative Faith that removes all temptation and possibility of looking at your paper. Stab a pen through the center of a piece of paper the same size as the paper you're drawing on.

2. Get your heart involved in the process by choosing a nearby object that sparks an emotional reaction or has a story that jumps out at you. As you tap into your object's story, let your emotional instincts guide your hand. This makes for more interesting, meaningful artwork.

I drew a fish-shaped cinnabar lacquer box on my desk, in which I keep my bottles of ink. I bought this box for three dollars at a thrift store on my birthday and I love it.

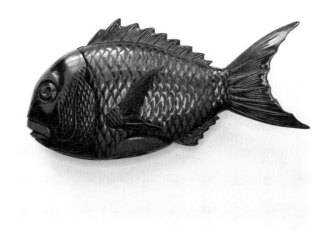

3. Set a timer for five minutes and begin drawing. You'll be surprised at how much you can accomplish. I won't be too prescriptive with my instructions because I want you to explore and trust your instincts.

4. Choose a starting point. I drew the fish in three sections, starting just above the big, round eye and working my way up back and forth around the contours of the mouth, working toward the chin.

5. Continue drawing the contour. I cut up the middle of the fish, drawing the line of the box's lid that fits behind the gills. I then drew the contour of the fish's upper body, working my way around the edge of the tail and around the bottom row of fins.

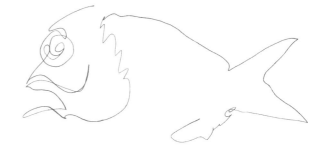

6. Add some details. I backtracked from the fins to draw the lines on the inside of the tail and worked toward the middle fin, making a few interior details as I worked my way around that feature.

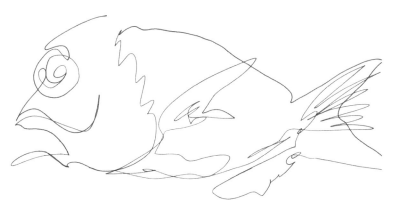

7. Complete the contour. I drew the belly and the bottom of the chin, working back toward the head where I began my drawing.

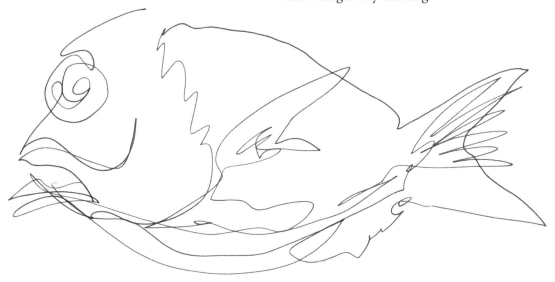

Don't get hung up on never lifting your pen. Use your line like a trail of breadcrumbs to find your way.

Blind Contour Drawing in Three Minutes

Try drawing another object, perhaps one you haven't paid much attention to before. Even if you don't draw every detail, use this time to notice them.

EXERCISE 3

Blind Contour Drawing in One Minute

Choose another nearby object or try drawing a person or an animal. Even in just one minute, you'll be surprised by how much you can capture—and notice—about your subject.

With blind contour drawings, we learn to evaluate our work in a new way, focusing on process and experience instead of perfection. After finishing all three drawings, ask yourself the following questions:

- What new things did I notice about my objects as I drew them?

- Without worrying about the final product, did I enjoy the process of drawing *more*?

- Was I surprised by the kind of details or essence I captured without looking at the page?

Now that you've mastered drawing blind, you should feel very confident drawing with the ability to look at the page. You can try these timed exercises again, making regular contour drawings. As you do, you might discover a new challenge: facing the blank page.

I made this blind contour drawing of my boyfriend in less than a minute. He's less scribbly in real life, but this captures his essence!

Finding the Hook

You're ready to draw. You open your sketchbook. The blank page stares back at you. Where do you start?

Should you close your sketchbook and move to a new country and pretend that you never wanted to draw in the first place? No. The fear of the blank page is real, but when it comes to the first marks, finding the hook will help you understand what—and where—to start drawing first.

The hook is a term I coined to describe how I begin a drawing. I start my illustrations by drawing what I find to be the most interesting, or eye-catching, part of my subject first.

The hook is your starting point and your reference as you navigate the rest of your drawing. Whether you're drawing a person, a plant, or an entire scene, the hook attaches your creativity to the page and becomes the gravitational point to which all other elements of your drawing relate.

Exercises: Finding the Hook

The following two exercises consist of first practicing how to find the hook and then incorporating it into a drawing.

EXERCISE 1
Finding the Hook in Two Easy Steps

1. Look around you right now. Find the first person or object that catches your eye and makes you think, "I want to draw that!"

2. Take a moment to look at your subject closely and let your eyes wander over it. Is there a spot your eye keeps coming back to? That's your hook, the first thing you'll start drawing.

A Scary Blank Page!

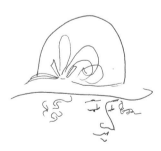

Your Subject

What a cool hat!

You found your hook!

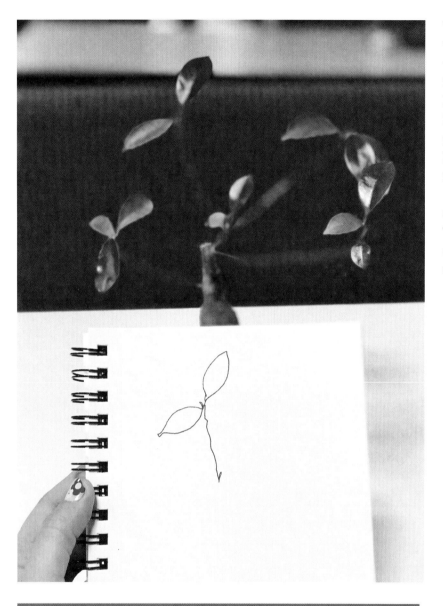

The top set of leaves in this money tree caught my eye because there was a reaching, optimistic quality in how they burst forth from the long, spindly arm of the plant, like little pom-poms cheering on the plant to grow. They became my hook, and the rest of the plant grew from this first set of leaves.

Determine if your hook also contains an essence of your subject. The leaves of the money plant were confidently reaching for the sky, embodying the spirit of this plant.

Artistic Choice or Mistake?

Don't worry if your first 500 drawings are too big or too small or if they're off center. Who cares? Learn to reframe mistakes as experiments in artistic choices. Instead of seeing these drawings as unbalanced or too big, think about how the placement and scale affect how you see the drawing.

In time your brain will get better at learning how to place the image on the page at the right scale. Until then enjoy the learning process and embrace your inner artiste.

Drawing the Hook in Two Easy Steps

1. Imagine the blank page is an empty frame. Think of your subject fitting nicely inside of that frame and place it there in your mind.

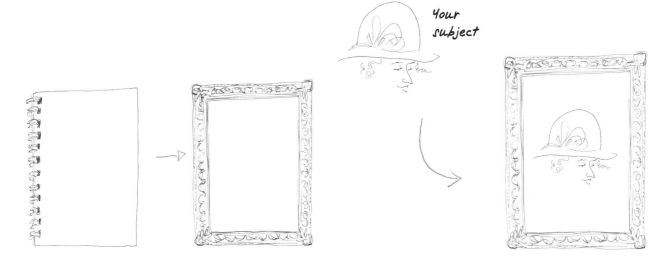

Your subject

2. Place your pen on the spot on the page where the hook would appear if your subject were framed as you've just imagined. Draw your hook.

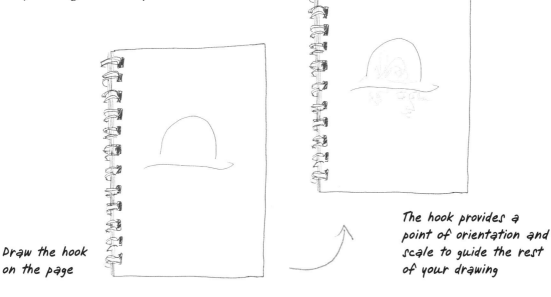

Draw the hook on the page

The hook provides a point of orientation and scale to guide the rest of your drawing

The size of the hook directly relates to the scale of your drawing on the page. Experiment with drawing the same hook in different sizes to see how it affects the scale of your drawing and how large or small your final piece will be.

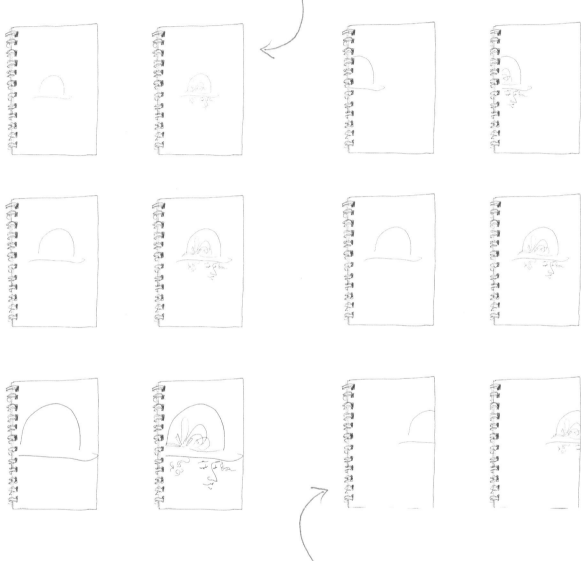

The framing on the page relates directly to the placement of the hook. Experiment with this too. Place the hook in different locations on the page to see how it affects the framing of your image.

Line Weight

Varying the weight or thickness of your line creates different effects in your drawings and adds interest.

Use lighter, thinner lines:

- To de-emphasize an element or add subtle detail
- To show that something is far away
- To contrast with a darker area
- To show texture or transparency

Use heavier, thicker lines:

- To add emphasis and draw the eye to a particular spot
- To create shadows, to make an object sit on a surface, or to create texture by showing the shadowed underside of a surface

Lighter lines suggest the bottle's transparency.

Though it's subtle, retracing select lines on a few pumpkins creates a sense of shadow, emphasizes the middle pumpkins, and makes the bottom pumpkins sit on the ground more firmly.

The interplay of lighter and heavier lines create texture.

THE MORE INTERESTED YOU
 BECOME IN YOUR SUBJECT,
 THE MORE INFORMATION IT WILL REVEAL.

DRAWING THE OBJECT

Things. Stuff. Doodads. Junk. Clutter. Background.

We have a lot of words to describe the objects that surround us, but how often do we really consider them? What would happen if we did?

We would discover that these collections have a lot to say. They not only tell us exactly how to draw them, but they can also tell us something about ourselves.

Before we can get to that, we have to learn how to talk to them. And to do that, we must learn how to bring them to life. We'll learn how to find the life within our objects and how to use that deeper understanding to make better, more expressive drawings of the things we see on the way.

Objects Have Feelings

Can a clock be sad? Can a teacup be joyful? Can a shoe be sassy?

Science has yet to prove that clocks, teacups, and shoes have deep emotional lives, but it is undeniable that we, as humans, have emotional reactions to the things that surround us. A clock can be sad if you're waiting for someone to return. A teacup can be joyful if it brings you happiness. A shoe can be sassy if it makes you feel that way.

Objects may not possess emotions, but they can certainly reflect them. It's worth taking the time to contemplate something as simple as a clock, a single flower, or a shoe for what it might reveal. This thoughtful way of seeing the world is reflected in the Japanese concept of *wabi-sabi*, a worldview centered on the acceptance and appreciation of things that are imperfect, impermanent, and incomplete in nature.

The wabi-sabi aesthetic values simplicity and intimacy and appreciates the process of creation, handmade objects, and the forces of time and nature. The lamp with the permanently off-kilter shade is a vessel that holds the story of years of family life it illuminated. Seen this way, we relish the wobbly lines on our page, as well as the humanity of the person who made them.

Wabi-sabi encourages us to find the most basic objects interesting, fascinating, and even beautiful and to find meaning in things as they are, not as they should be. Consider your on-the-go drawings the same way: an imperfect, time-bound, appreciative experience of the world around you.

How to Interrogate the Object

As visual storytellers, we need to understand the objects we draw. The better you know your object, the better you'll be able to tell its story on the page.

Interrogating the object is a method of bringing an inanimate thing to life by asking questions about it. Though this phrase makes the process sound intense, you don't need to play good cop/bad cop with your object; just have a friendly conversation with it, and it will reveal interesting details and hidden emotions.

You can interrogate an object in three simple steps: ask it, understand it, and draw it.

Asking the Right Questions

1. Ask the object questions like "What's happening?" "What am I seeing?" "What are you made of?"; "What's going on here?"; "How do you work?"; or even, "What happens next?" Questions like these help deconstruct the object and reveal what elements you need to pay attention to as you re-create it.

If you're drawing a tree, and the only information you have is that it's a tree, you will have to do a lot of work to transcribe it on the page. But if you ask what the tree is made up of, it will reveal its composite nature to you: leaves, stems, bark, branches, knots, swirls, and all sorts of small details. When you become curious about those details, they become clearer to your eye as you represent them.

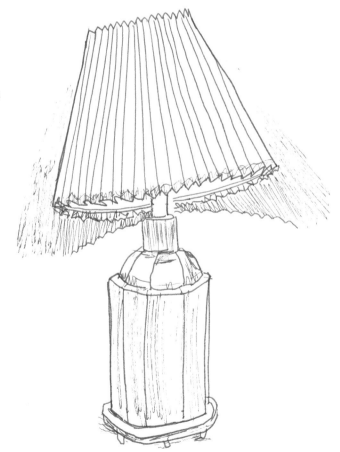

I find this approach of interrogating the object most helpful when working with inanimate things, but you can also use it to better understand people and animals.

2. Understand it. If you don't know what element to draw next on the tree, try asking questions such as, "What are you made of?"; "What's going on here?" As you answer these questions, you'll narrate your observations about the object, which creates a timeline: first draw this, then that. Step by step, the object unfolds before you as you transcribe this experience—and your understanding—on the page. Understanding your object in this way also animates it, changing it from a static thing to an active one. The process of observation will reveal it's order and organization.

3. This step is the easiest: draw your subject! Now that you've engaged with and understand your object better, draw what you learned about it on the page.

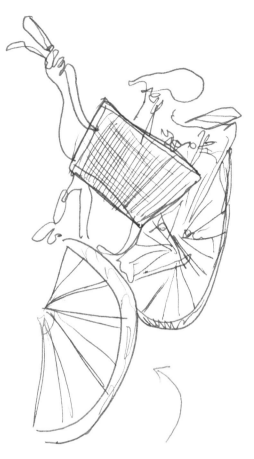

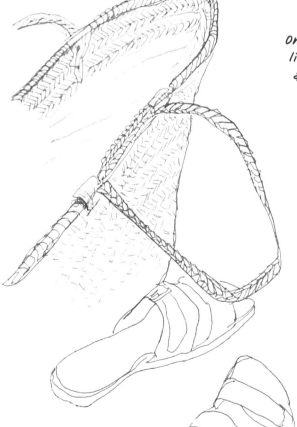

Once I'd drawn the front wheel of this bicycle, I was a little lost—so many wires, handles, and metal bits! I asked, "What happens next?" and the basket came into view. I asked, "How do you work?" and I saw that the basket was just a simple trapezoid shape filled in with a hashmark pattern. Next I saw a handle sticking out from behind, and then a seat, and I kept asking questions until a bike appeared.

I didn't know how to draw the complicated mechanics of a woven straw bag, so I asked my object for some help. The answer came in a series of easy to understand—and draw—patterns. I noticed the way the woven straw formed rows, so I marked those in first. Then I noticed how the pattern of the weave was made up of slanted lines with rows leaning in opposite directions.

Two Ways to Understand

Now that you've begun to consider the object more deeply, you are naturally engaged in the process of understanding it. There are two kinds of understanding: practical and emotional.

Practical Understanding: Practically understanding an object means we know how it's physically put together, and we can transcribe it on the page. To grasp the more complex aspects of an object, I'll ask, "What does it do?" or "How does it work?" I describe the thing in the easiest way so that my pen can express that.

Interrogating an object is also helpful when you're trying to draw something that you're already familiar with, such as braided hair. I know braids are made by weaving three strands of hair together, but that can make it harder for me to figure out how to draw a braid. But when I ask, "What do I see?" I notice that the braid makes a heart-shaped pattern, and I simply recreate this new understanding with my pen.

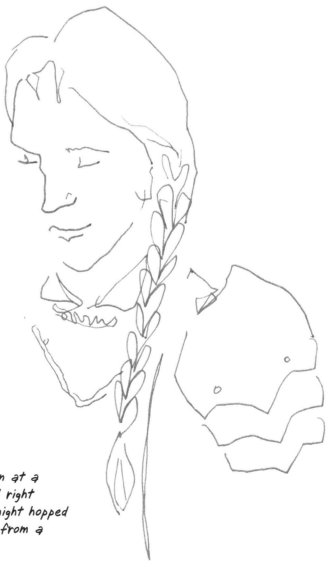

This image was drawn at a Renaissance festival right after this female knight hopped off her horse fresh from a round of jousting.

Emotional Understanding: Emotionally understanding an object means we understand its spirit or essence. We've acknowledged that objects have ascribed emotions, so tap into those. Registering an object's emotional importance will make for a more interesting, and what I call storyful, rendering of it and help you organize the information you're gathering.

If you're drawing a tree in early spring and its branches are adorned with thousands of buds, you can't possibly draw each one. Consider the emotions and purpose of the buds and the story they're telling. A tree that's laden with buds is both bare and bursting with potential. Seen this way, the chaos of a million buds is organized by their story, helping you notice how the buds concentrate on the outer edges of each branch, while the main trunks of the tree are bare.

With this emotional perspective, you'll realize you don't need to draw every bud, just capture the feeling of a tree that's about to transform. The drawing becomes the story of a tree in spring, rather than simply a drawing of a tree. Remember to draw what you feel, not just what you see.

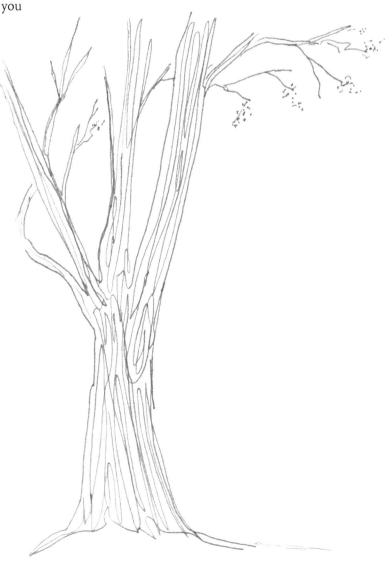

Exercise: Interrogate and Draw a Tree

Interrogating an object makes hard things easier to draw by guiding your head and hand to a greater practical and emotional understanding. I'm using a tree for this exercise because (confession) I don't like drawing trees. I like trees, but I find them difficult to draw. So, let's see how a little interrogation can help me.

1. Begin by drawing your hook; a general outline will get you started (for more on the hook, see page 36). My hook was the trunk of a lush maple tree in full leafy bloom, and I traced its general contour.

2. I'm not sure what to do next, so I look at the tree's canopy. It's large and filled with thousands of leaves. I'm overwhelmed, so I begin asking questions about what I'm seeing. Do the same with your subject; ask, "What's going on here?" This question prompts me to see the canopy as a a cloud shape. I block out the canopy with a light outline, leaving an opening where I can see a bit of sky. We'll add more details as we ask more questions.

3. Once you have the basic construct, it's time to add more details. Ask the question again, "What's going on here?" I draw the little gaps in the canopy where some large branches peek through, scribbling my pen back and forth to darken them and make the rough texture of bark.

4. Each new question increases your understanding and builds another layer of your drawing. I ask, "How do those leaves work?" They seem to grow in bunches, almost like clusters of grapes, and are flat, pointed, and rest on top of each other in layers. I try to find the pattern or gesture I can make with my pen to render the leaves without drawing every single one; I draw clusters of jagged scribbles and layer them to replicate the way the leaves appear on the tree.

5. Continue asking questions with each new detail that catches your eye. Experiment with adding lots of detail or adding very few details that are telling. It doesn't take much to communicate an essence of something when you deconstruct your object in this way.

The bark is striated and rough and swirls around two large knots. I draw long swirls, mimicking the patterns of the bark and the knots. I retrace and darken some of the lines inside my branches to make them heavier, showing the shadows and depth of the rough bark. I do the same where the large branch splits under the canopy to show it's in shadow.

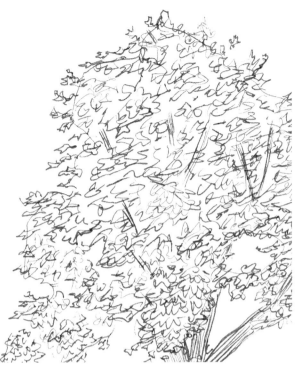

6. If you're almost done, compare your drawing to the object. This is often where I notice some small detail that speaks to the whole, captures its spirit, and completes the story.

I see individual maple leaves on the outside edge of the tree's canopy; they make the tree feel alive, and I realize this is what my drawing is missing. I add individual leaves sporadically around the edge of the canopy line. By doing this, I cover up my original line, making the canopy shape more organic.

7. Make a final comparison between your drawing and your subject and pose one more question: "Is there anything else I should have asked?" I add a few more branches in the canopy and darken the bark to make the contrast match what I see. I retrace the bark to make thicker, darker lines where the trunk and branches are in deeper shadow. I drop in a few extra branches between clusters of leaves, scribbling back and forth a few times to create the texture of the bark and darkening up these branches that are in shadow.

I've created a tree by simply asking questions, answering them in my mind, and then drawing the answer on the page. The tree told me everything I needed to know to draw it!

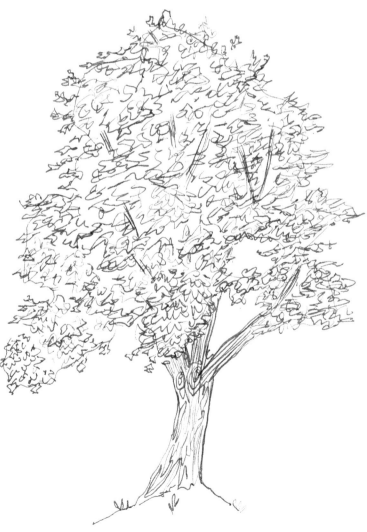

COMPOSITION IS HOW YOU SEE THE FOREST
FOR THE TREES

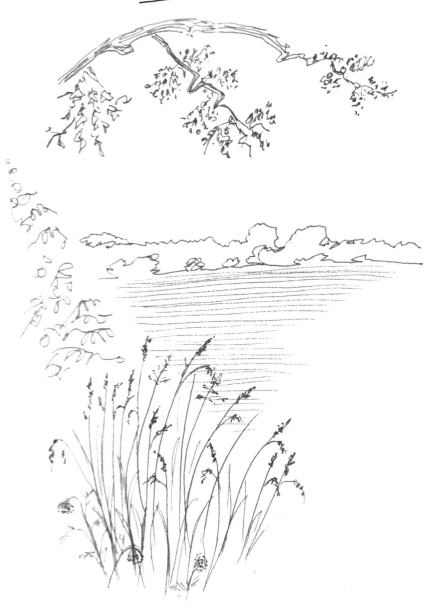

CHAPTER 5

DRAWING SCENES AND BACKGROUNDS

You're out in public, and you're ready to draw, but there's so much going on.

Distilling a complex scene into something that makes visual sense and tells a story can be challenging. But you don't have to feel overwhelmed deciding what to include and what not to include in your drawings.

We'll discuss how to bring your own artistic order to the joyful chaos of the world. You'll learn how to find your point of view and how to use compositional techniques to show relationships and tell stronger stories. You'll also discover how to build a scene and easily manage scale and proportion without rulers or grids.

Your story is waiting. Let's start telling it.

Editing a Scene to Reflect What You See

One of the lovely things about drawing from life is the way it makes you see the world. No matter where you go, the scene before you is no longer just another mundane, everyday place—it's a potential source of inspiration for your next masterpiece. This transformation makes the commonplace more exciting, but it can also make it overwhelming. When everything is interesting, how do you decide what belongs on the page and what doesn't?

Because there are a million stories playing out in any given scene, it's your job to see them and decide which you want to tell.

I call the search for the story *zooming*. As I scan the room, I imagine myself as a camera lens, zooming in on smaller details or zooming out for the larger scene. In a café, I might zoom in and draw my hand resting on a cup of coffee. Or, I could zoom out a bit more and draw the nearby tables. Zooming out even farther, I could draw the whole café, or I could expand once more and notice the dog sitting patiently outside.

What You Already Know

I'm going to ask you to help me prove a point, and I don't think you'll mind when I say, "I told you so!"

Create a drawing that encapsulates the scene in front of you. Don't overthink it, just start drawing. Don't take more than ten minutes.

Set the drawing aside and look at it again when you've finished this chapter. I guarantee you'll have employed some of the compositional techniques I'm about to share with you, proving my point. You're already familiar with many of these concepts because you've spent your life passively learning about them from museums, children's books, and magazine ads—anywhere an artist has created something.

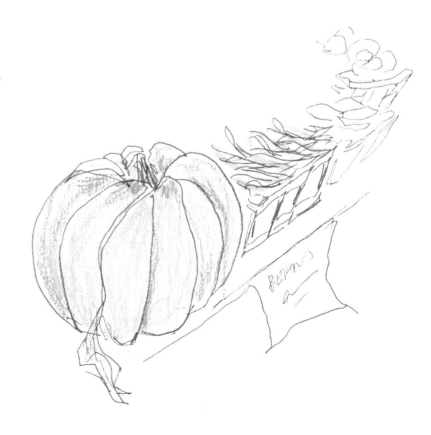

Exercises: Capture What You See

The following two exercises ask you to first zoom the room and draw an entire scene and then change your perspective and focus on smaller details that tell individual stories.

EXERCISE 1
Zoom the Room

1. Scan the room and ask questions about what you're seeing; it can be tempting to dig right in and draw the first thing you see. Take a moment to absorb the energy of the space and choose the story you want to tell. Notice the energy, décor, body language, how people are dressed, and think about who people are and imagine their stories.

2. Think about what strikes you as interesting and wonder why. I was struck by a nearby couple whose conversation was occasionally interrupted by a shy laugh or awkward pause. I drew the couple, noting his listening eyes, her shy smile, and their open body language. Since they were closing down the place, I added a few empty tables and chairs and the waitress cleaning up at the end of her shift.

3. Zoom in and out to find different stories and new points of view. I saw a spontaneous still life before me: an endlessly refilled cup of coffee, a good book, a small vase of flowers, and my phone pushed off to the side. The sum of these parts added up to describe a slice of my life as I relaxed at a local café.

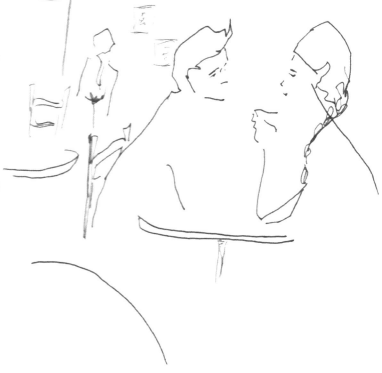

Change Your Point of View

Use the zoom the room technique to discover and draw three different stories from the same scene. Take thirty minutes to do this exercise. Use the time limit to prevent overthinking and spark creativity.

1. Zoom all the way out to tell the story of the entire scene you're looking at. In a park, draw the whole playground including the children, parents, trees, and paths. At the airport, draw the travelers, gate agent, signs, and luggage filling the aisles, even the planes waiting outside. In a restaurant, draw the decor, plates of food, the diners, and waiters. If you're struggling with rendering perspective, see page 83.

2. Zoom in a bit more. Tell the story of the two little girls playing tag, or the weary traveler asleep on their luggage, or the waiter pouring wine.

3. Zoom in even more. At the park, tell the story of a pair of shoes and socks left behind by their owner running barefoot through the grass. At the airport, draw the ticket anxiously clutched in a fearful flyer's hand. In a restaurant, draw a drink garnish.

After you've tried this exercise, notice how you see the world differently even when you aren't holding your sketchbook.

What to Include and What to Leave Out

Don't feel obliged to capture every little aspect of a setting. A few, well-chosen details can say much about the view. A simple line can represent the ocean's horizon, a window, or the edge of a table. Think of your scene as a pie and your drawing as a piece that represents the whole.

Using Composition to Tell Your Story

You've zoomed the room and found your story. This is where composition comes into play. Composition is the technique of assembling elements of your drawing in a way that effectively communicates your story and actively engages the viewer by inviting them into your scene.

Instead of overwhelming you with lots of rules, I'm going to share three simple ideas for you to consider. Think of these ideas as tools, not rules—general principles whose main purpose is to help you be a clear and effective storyteller.

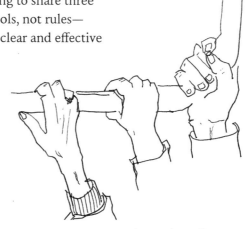

Rhythm

Ever find yourself bopping along to the beat of a good song? That beat organizes the music into repeating patterns and gets listeners immersed in the song. Rhythm in a composition works in the same way.

Visual rhythm happens when details or elements repeat, creating a feeling of organized movement. Our brains are attuned to visual rhythm because recognizing patterns is how we organize our world.

Repeating themes, ideas, or visual elements create rhythm.

Pattern is the repeating of an object or symbol all over the work of art and can often be found in fabrics and clothes. Rhythm is different from pattern, but pattern can help create rhythm.

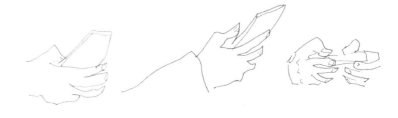

Repeating elements communicate with the viewer, underscoring themes or speaking to what isn't shown. A row of subway commuters holding their phones creates a visual rhythm that speaks volumes about what is happening (hiding out in technology) and what isn't (reading, engaging with the world).

Balance

Balance is the distribution of the visual weight of objects, colors, texture, and space on the page. Think about your drawing as an old-fashioned scale. As you add elements to it, you can balance them in different ways to achieve different effects:

Positive and Negative Space: When you draw, you affect the balance between the negative and positive space. The space you leave empty (negative space) says as much as the space you fill (positive space). Each has a role in creating balance. When creating a composition, think about how both kinds of space interact with each other to tell the full story.

Visual Weight: As you add more elements, imagine you're adding weights to a scale. Elements with more visual impact have a greater weight, and the eye will naturally focus on them. Increase visual weight by adding more detail, pattern, or color to an element. Play with areas of positive and negative space to direct the eye. Areas of detail attract the eye, and negative space gives it a place to rest.

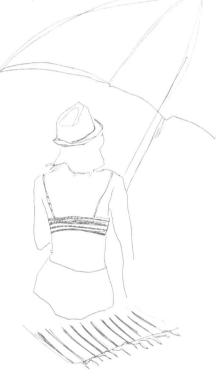

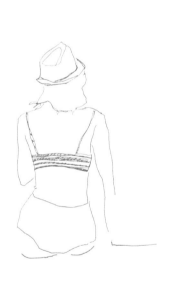

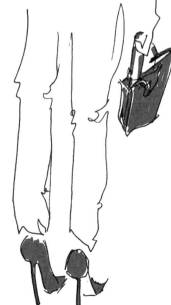

Visual weight is like a spotlight on the stage, helping the viewer better follow the story. Here, a pop of color highlights the matching handbag and heels.

This single beachgoer looking out into negative space suggests a mood of contemplation or loneliness. Placing that same figure in a sea of people, or even adding an umbrella, changes the mood to something more fun or relaxed.

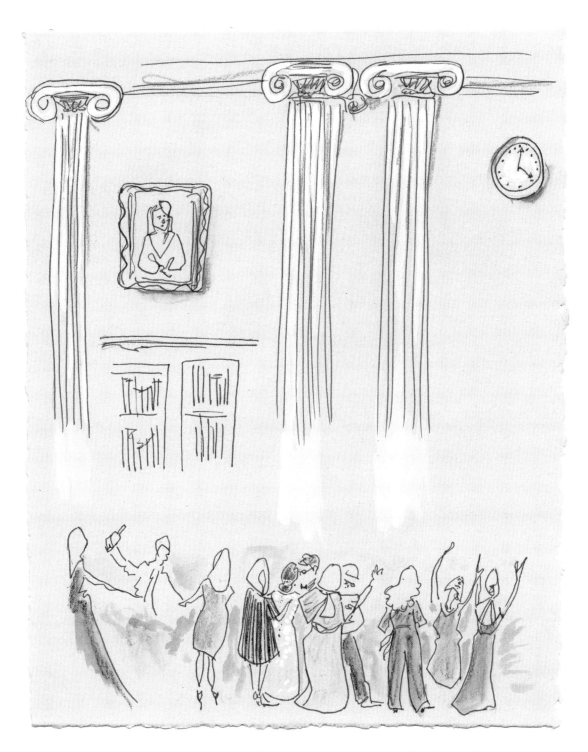

This bottom-heavy composition creates a contrast between the high ceilings and formal space of the wedding reception, encouraging the eye to travel down to the crowded dance floor where the action is happening.

Scale and Placement: Where you place elements and how big you make them affect balance. To re-create the feeling of watching trapeze artists at the Big Apple Circus in New York City, I placed the performers in the top right corner and drew them on a small scale with few details.

These compositional choices tell a story; the negative space becomes the air that our performers will fly through. Scale and placement and weight suggest the distance from the viewer and the danger of this high-flying entertainment.

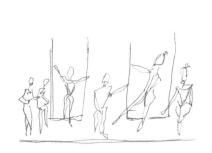

That's Odd

An odd number of elements in a composition makes for more interesting, natural relationships and keeps the eye moving throughout. If you're ever stuck on a composition and you notice that it's looking stiff or boring, think about the grouping of objects within it.

Movement

Have you ever gotten lost in a piece of art, wandering through the scene on a journey with your eyes and mind alone? This is movement. Movement is how your eye navigates an image and is a great way to engage viewers with your story. Rhythm and balance create movement, as do design elements like color, shape, or texture.

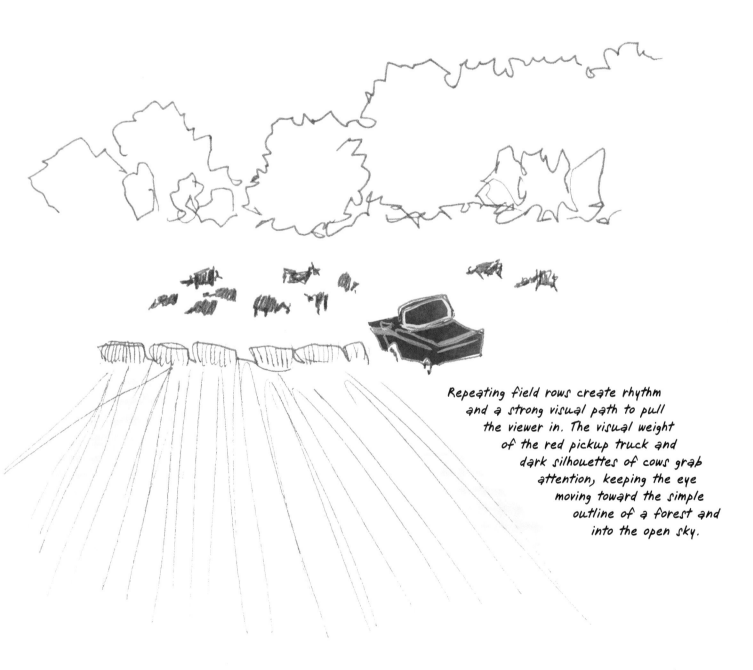

Repeating field rows create rhythm and a strong visual path to pull the viewer in. The visual weight of the red pickup truck and dark silhouettes of cows grab attention, keeping the eye moving toward the simple outline of a forest and into the open sky.

Composition Underscores Connections

Composition not only communicates your story, but it also defines the relationships among the elements in the scene. See how the following drawings incorporate the principles of rhythm, movement, and balance to enhance the narrative.

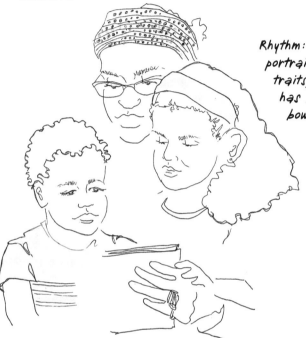

Rhythm: If you're drawing a family portrait, rhythm can highlight shared traits, like this family where everyone has beautiful curly hair and cupid's bow smiles.

Balance: Use balance to convey emotional and physical relationships. Letting small things take up a lot of space increases their importance, like this drawing of pots and pans on a cramped stovetop in a New York City ramen shop.

Movement: One flowing, unbroken line can merge two or more people into one, conveying intimacy and interconnectedness.

Exercises: Composition

In the two exercises that follow, you'll build a story using the principles of rhythm, balance, and movement to immerse the viewer into your setting.

EXERCISE 1
Creating a Compelling Composition

The process of creating an in-the-moment illustration is a mixture of planning and improvisation. Using compositional concepts organizes your approach as you work. Here's how they helped me draw this farmer's market vendor and her cheerful flower stall.

1. Choose a scene (don't second-guess what inspires you) and begin your drawing with your hook. Mine was the daisy-like yellow flowers that caught my attention as I walked past the market stall.

2. Add more details to your story, considering how each element might engage your viewer.

I drew the rest of the flowers, the buckets, and the table using compositional techniques to pull the viewer into the scene. The tangle of flowers and stems and pops of color create a heavier spot on the page (balance), and the red and yellow move the eye across the flowers (movement). I organized the chaos of the stems into a series of vertical lines (rhythm). (To see more on adding color, see page 116.)

3. Have you told the story you wanted? I considered making this a short story about lovely market flowers, but decided I wanted to add the vendor. As you add more elements, consider how composition can underscore the story.

The flowers are the star of my story and the vendor is the secondary plot line. Compositional elements (weight, movement, and rhythm) lead the viewer to her after they pay attention to the flowers.

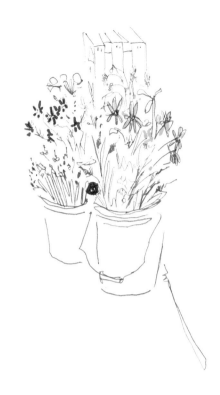

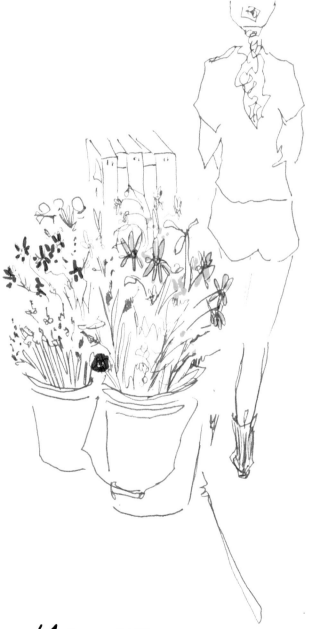

4. To keep the eye moving beyond the flowers to the vendor, I drew the crate behind the flowers. The repeating lines of the slats echo the leading line of the table (rhythm) and encourage the eye to move farther back into the piece (movement).

5. I drew the vendor from the top down. (See more on drawing figures on page 83). No advance planning was required to leave space for her. My viewpoint made that compositional choice for me, and she naturally fit into my drawing. You're close to completing your drawing, so make sure you haven't omitted any critical story elements. Are the who, what, why, (when, if it's important) and where clear?

6. Provide more context of the setting. I drew the crates and baskets behind the vendor, adding more detail to the baskets (balance) to encourage the viewer to spend more time in the background with the vendor (movement).

Assess the final composition by seeing if your eye travels the same path on the page as it does looking at the scene. If so, you've got a great composition, and your viewer will read your image in a similar way. (For more on drawing perspective, see page 83.)

(For more on drawing perspective, see page 83.)

EXERCISE 2

One Story, Told Three Ways

Zoom the room and find your story. Tell that same story three different ways, focusing on balance, then rhythm, and then movement. You'll have three different drawings. Take no more than thirty minutes for this exercise.

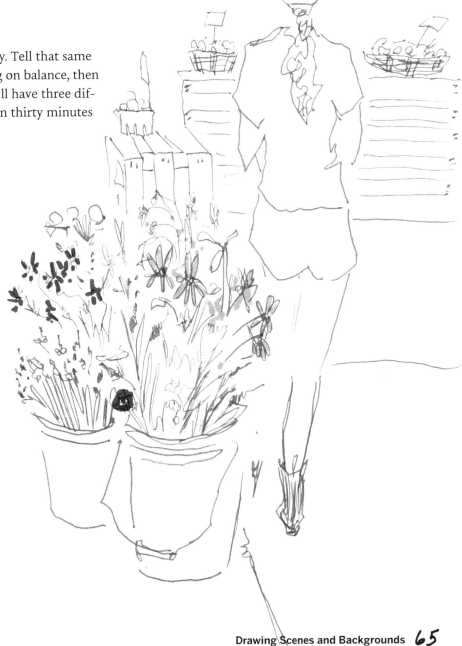

It's All in the Details

Consider how much detail each new element in your drawing merits and how it affects the composition. Since my vendor isn't the focus of this story, I added minimal details to her figure. I darkened her boots (balance) to pull the eye down her body (movement) and bring attention to this detail that speaks to her farm-to-market lifestyle. I colored her boots with vertical scribbles, mirroring the vertical lines of the flower stems (rhythm) and keeping the eye moving from her figure back to the flowers (movement).

Drawing Groups of People

Because you're drawing on the spot, there's no time to build elaborate grids or complicated overlays to manage scale and proportion. To solve this problem, I use imaginary measuring sticks to determine proportion and scale.

Proportion refers to the size of an object's parts in relation to its other parts. Within a single person or element, you're managing proportion.

Scale refers to the size of objects in relation to each other. In scenes with multiple objects or people, you must manage the scale of those elements in relation to each other.

For my method for establishing scale, the first element you draw becomes the measuring stick for the second element. After you've established this scale, you can determine the size of subsequent elements by measuring them against any existing element. This method works well for improvisational drawing because it's flexible and relational.

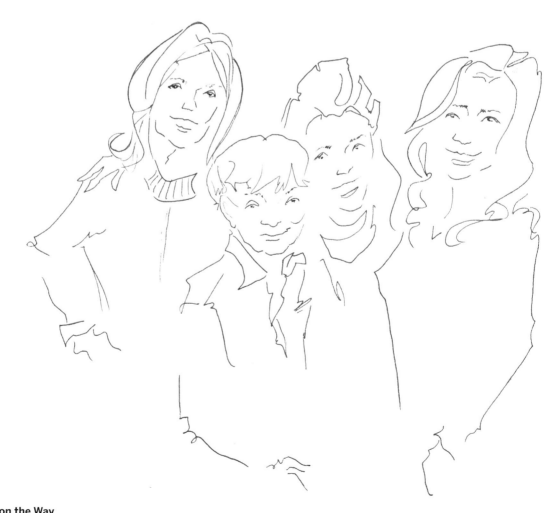

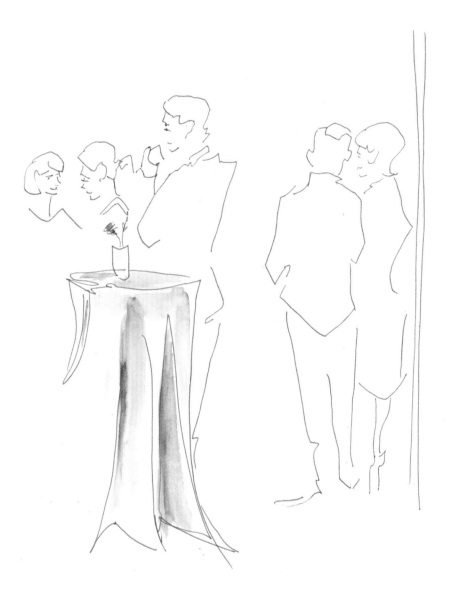

To create scale, you need to create a unit of measurement. When you're drawing, you can turn an element into a measuring stick in a couple of ways:

Impromptu Units of Measurement: When drawing a person, you can measure their figure by how many heads high they are. (For more on drawing figures, see page 82.) In this case, a head becomes your unit of measurement. When drawing figures of different heights, use this method to manage scale, so one figure might be a head taller than another.

Points of Alignment: Choose a natural point of demarcation on each of your objects and note where those points align. The top of the head, the line of the shoulder, or the waist are great points of alignment on the human figure.

When using this method to draw figures of different heights, use a point of alignment to determine comparative size. For example, the taller person's jaw might hit at the same point as the top of the shorter person's head, as in the family portrait on the previous page.

Managing Scale and Proportion

For this exercise, you'll take what you've learned about scale and proportion and apply that to drawing a scene that catches your eye, with an emphasis on how the elements relate to each other.

1. Draw your hook (for more information on drawing the hook, see page 36). This first element is your measuring stick. I was at a wedding, and I drew the bar where people were standing.

2. Draw the second element and use an impromptu unit of measurement or points of alignment to calculate the relationship to your measuring stick.

My second element was an elegant woman waiting for her drink. I used points of alignment, noting that her waist aligned with the bar, her shoulders aligned with the first row of glasses, and the top of her head aligned with the bottlenecks.

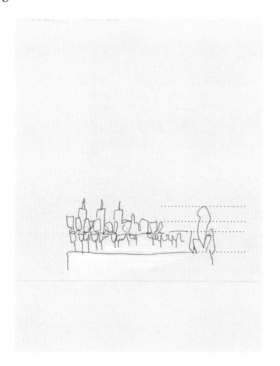

3. Once you've drawn two elements in relation to each other, you've established a scale. Any new elements must be measured against any existing element, using either impromptu units of measurement or points of alignment.

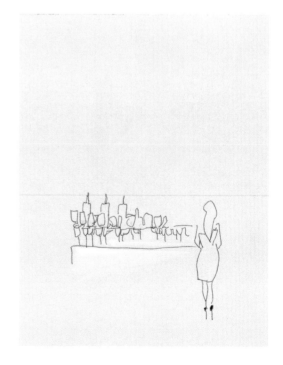

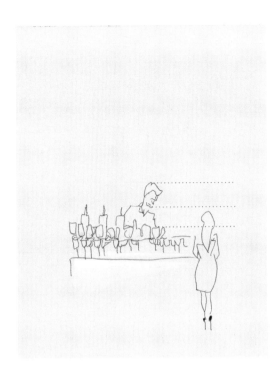

4. I drew the bartender using his head as an impromptu unit of measurement. He was about two heads higher than the top of the glasses and about one head taller than the woman.

5. I included a painting of a sailor above the bar because it communicated the unique venue of this wedding: an art museum. The sailor was about as tall as the woman below, so she became my impromptu unit of measurement.

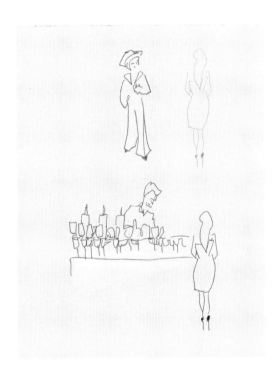

6. I estimated that the width of the frame was about the same height as the sailor's face, so that became my impromptu unit of measurement. I added a few more details and some watercolor to complete my scene.

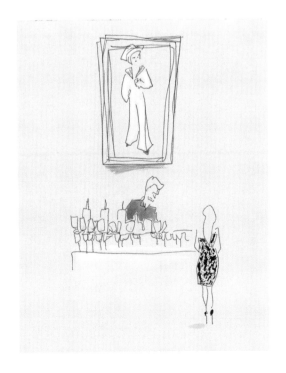

Point Proven: Now that we're at the end of the chapter, look at the drawing you did at the beginning. I told you so!

NATURE IS
NOT A DESTINATION,
IT IS EVERYWHERE

DRAWING NATURE AND ANIMALS

Nature is an excellent place for practicing the foundational skill of on-the-go drawing: observation. Natural things are full of life, and unlike people, they aren't self-conscious or impatient.

I'll show you how to quickly and expressively render the natural world, whether it's an entire forest or a single potted plant. We'll explore how to draw creatures that don't stand still. (If your plants start moving, I can't help you with that problem.) You'll learn about capturing the spirit of animals, both tame and wild, with whom we share our world.

Drawing Natural Scenes

No matter where you live, you are never far from nature. Even a city like New York is full of nature, and not just in Central Park. It's in bouquets at the bodega, tumbling out of produce bins in grocery stores, growing out of cracks in the sidewalk, and planted in window boxes. Although no one likes to admit it, pigeons are just doves by another name.

Nature Safari Expedition

Nature is everywhere, but sometimes you have to look for it. This physical exercise will help you do just that. Wander through your neighborhood and don't stop until you've found at least ten different natural things. As you walk:

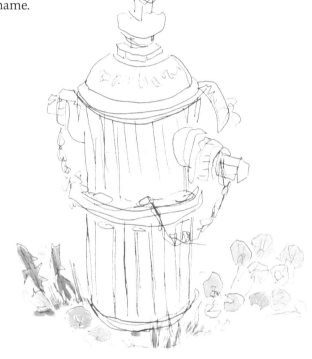

- Be expansive in your definition of *nature*. The flowers in the flower shop, potted plants, and city sidewalk trees are made of the same natural stuff you'll find in the country.

- Keep your eyes moving. It's natural to look down as you walk, but keep your head on a swivel and you'll see so much more.

- Wear comfortable shoes and clothes. This might sound obvious, but observing the world around you is more fun when you're comfortable.

Try this exercise again at the end of this chapter— this time, with your sketchbook in hand.

Exercises: Nature Drawings

In the next three exercises, you'll study a subject in nature and re-create its arrangements, patterns, and form in your drawing using the stamping technique.

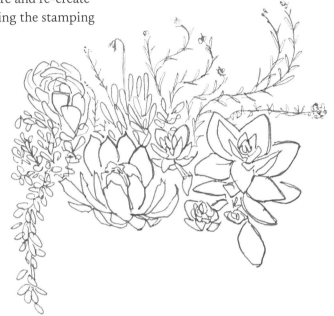

Stamping: Re-creating Nature on the Go

Natural things—especially botanicals—may seem chaotic, with branches and leaves going every which way. But when you observe them with a mind to find the underlying structures and patterns, you'll discover a lot of symmetry and repetition in nature.

You can use the process of interrogating the object (see page 45) to better understand your natural subject. Then, you can use a technique I call *stamping* to quickly layer and build your nature-focused illustrations.

This technique incorporates memorizing repeating shapes and stamping them, or drawing them repeatedly, on the page. Once you understand what ingredients are used to make up a tree or a spray of flowers, you can add them at will. You don't have to draw every detail, and you can spend more time focusing on your sketch and being more thoughtful with your composition.

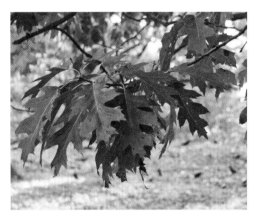

EXERCISE 1
Drawing Oak Leaves

1. Study the natural scene or object in front of you and look for patterns. Notice the shapes of leaves and petals. Observe the underlying structure that supports them; how do they attach or arrange themselves on a branch or stem? How do they grow?

2. I notice that the oak leaf is symmetrical, with four notched lobes on each side and one at the end. Once you know how to draw one side, you can draw the whole thing.

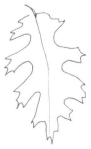

3. In this cluster of leaves, some can be seen straight on and some from the side. I apply what I see to create the side view stamp.

4. Look for the underlying structure of your subject; this could be a flower petal formation or the curved stems of tall reeds. These leaves grow from a branch. If we imagine all the leaves falling away, it would look like this.

Once you understand the basic patterns and shapes, commit them to memory so that you can stamp, or repeat them, on the page. You can still look at your subject for reference as you work.

5. Add the repeating natural elements to your drawing using the memorized shape or pattern. It may help to first draw some of the underlying structure and then add your stamps. Or, you may prefer to stamp first and add the structure afterward.

I drew the branch first, as a sort of scaffolding. I added leaf stamps using a mix of front and side views and smaller and larger leaves. To fill in behind the larger leaves and add volume, I drew just the part of the leaf I could see.

Nature is not perfect, but it does repeat. The variation inherent in each stamp you draw mirrors the kind of imperfect repetition found in nature.

Drawing a Cluster of Flowers

1. Observe: Take a moment to observe and find the hidden order and repeating patterns. Think of your observations like you're creating a recipe and create an ingredient list. I noticed that each flower is made of three simple elements: a central column, petals, and a stem.

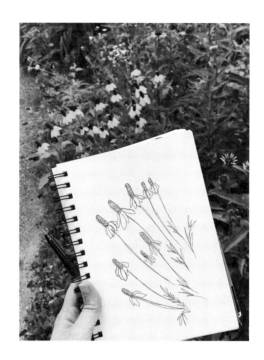

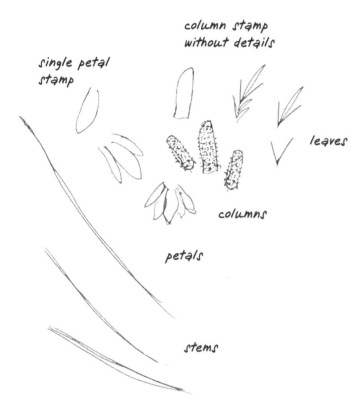

single petal stamp

column stamp without details

leaves

columns

petals

stems

2. Memorize: Memorize your observations so you can easily cook up your drawing in the next step. As you deepen your observation, think about what words come to mind and what stamp might represent them. I notice that the central columns of these flowers are lined with rows of thin filaments, the petals are paddle-shaped and the leaves grow in thin, arrow-shaped pairs.

3. Stamp: Assemble your ingredients to make the final dish and compose your image using your stamps.

I drew the flower stems first, creating the underlying structure for layering the flower stamps. Next, I built each flower by stamping the column, petals, and leaves. I added the cone's finer details last. Working this way, I was able to look at my page more and have more creative control.

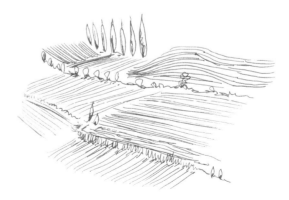

You can use this technique on larger natural scenes, too. I stamped crop rows, hedges, and trees for this view outside my train window.

Drawing a Backyard Scene, Working Foreground to Background

Even in quick sketches, you can create a sense of depth in scenes by distinguishing between foreground and background details. If you're working in pen or other indelible media, create layers without crossing back over existing linework by first drawing what's closest to you and then adding things in the background. You'll naturally leave space for background details that fill in around foreground elements to create the illusion that things are resting on top of each other.

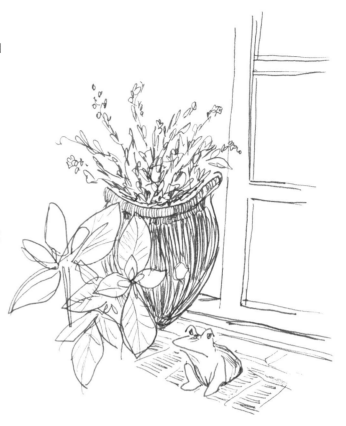

1. To draw a layered scene, block in the foreground shapes first and then work backward, away from you, blocking in the shapes of each receding layer. In this backyard scene, there are three layers: the leaves, the flower pot sitting on bricks, and the glass doors.

2. Draw the outline of the leaves in the foreground first and then tuck the outlines of each new layer behind the last. I outlined the flowerpot, roughed in the flowers, and sketched the frog. Finally, I added the outlines of the doors.

3. Once the overlapping shapes are blocked in, add finishing details, such as leaf veins, shadows, and textures. I added the veins on the leaves using the stamping technique, finished the flowers, marked the grooves of the bricks, added details to the toad's face, colored in the large ceramic pot, and added emphasis to the areas of shadow.

Drawing Pets and Other Animals

Animals are known for living in the moment, and you can sketch them in a minute—and be in the moment with them—using this fast, simple approach.

In this four-step method for drawing an animal, you'll proceed one section at a time, using your line to suggest texture and character, and adding your finishing details last. You can begin by working from the top down or by starting with your hook. No matter where you start, the process will be the same.

The Top-Down Method

1. Visualize the animal as a series of distinct sections and basic shapes. Though you won't draw these on the page, this exercise will help you simplify and understand what you're about to draw.

2. Start drawing the head and work through each section, one at a time, using the contour line drawing technique (see page 29) to trace the outline. Depending on the animal's pose, the top-most point may not be the crown of the head; it might be the nose or even the rump.

When I draw animals using the top-down approach, I often start with the ear, work down the face, and then move onto the body. Ears are natural anchor points; they can be used to manage proportions and communicate a lot about an animal's personality, character, and mood.

Step 1

I can only see three legs, so my shapes reflect the pose and my viewpoint.

Step 2

Draw the topmost point first.

3. Work each section to the same point of completion before you move onto the next. This helps to manage proportions and prevents overworking one section.

Use your line to not only to define each section's outer perimeter, but also to suggest its texture. I vary my line so that it communicates more than just shape. For a scruffy dog, my lines are messy because that's the texture of its fur. If I were drawing an eel, I'd make my line slippery and fluid.

Use as few lines as possible for each section. This maintains the flow of your drawing and connects each section to the next, so the animal feels alive, not disjointed. Refer to the blind-contour drawing exercise (see page 32) and let the topography of each section lead you to the next.

4. Once the basic outline of each section is finished, determining the animal's overall shape, add finer details. Try using the stamping technique for adding features (see page 73).

A bird, with its sleeker shape, and seen from farther away, yields a simpler drawing, but the process is the same.

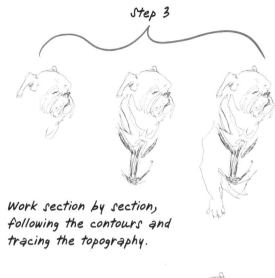

step 3

Work section by section, following the contours and tracing the topography.

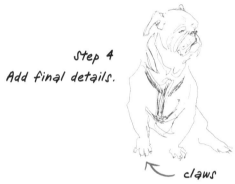

Step 4
Add final details.

← claws

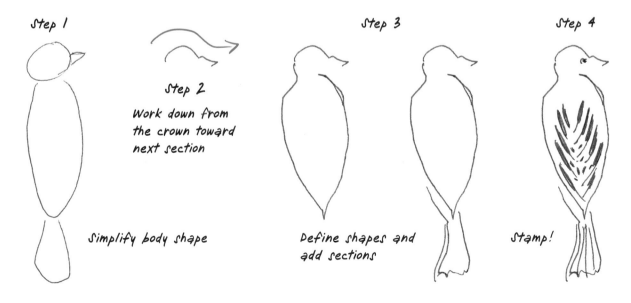

Step 1

Simplify body shape

Step 2
Work down from the crown toward next section

Step 3

Define shapes and add sections

Step 4

Stamp!

Starting with the Hook

This process is similar to drawing top-down, but you begin drawing with your hook instead of the animal's top-most point. I use this method when some part of the animal catches my eye and I want to enter the drawing through that point, which could be a forelock, a curl of a tail, or a hunched shoulder.

Here my terrier's pricked-up ears are the hook; they also vie with the nose for the top-most part.

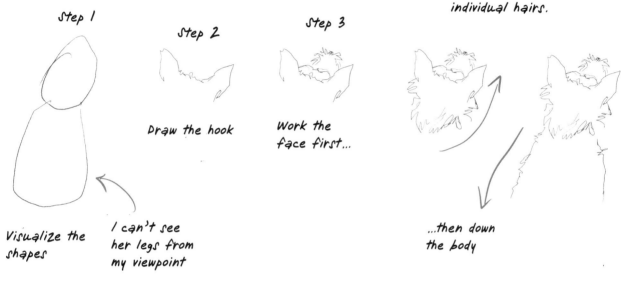

I skipped Step 4 because I liked this simple sketch as is! I could have added a collar or individual hairs.

Step 1

Step 2

Step 3

Draw the hook

Work the face first...

Visualize the shapes

I can't see her legs from my viewpoint

...then down the body

In this quick, 30-second sketch of a chicken, I drew the tail first, since the fin-like shape was the first thing that caught my eye on this fluffy-bottomed hen.

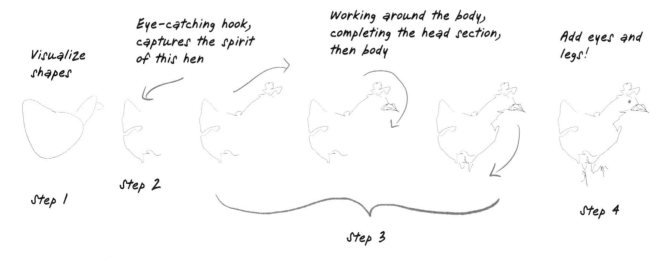

Visualize shapes

Eye-catching hook, captures the spirit of this hen

Working around the body, completing the head section, then body

Add eyes and legs!

Step 1

Step 2

Step 3

Step 4

Drawing a Moving Target

Drawing my dog Hildy is one of my favorite things to do. One of her favorite things to do is change her pose when I'm halfway through a drawing. This is the biggest challenge of drawing animals—they move!

Over time, I noticed that if I was patient, my dog would eventually return to her original pose and I could finish my drawing.

Animals (and people too) tend to have a limited repertoire of movements. If you've ever spent time watching a cat or dog, you'll notice they rotate between a few movements and postures. They sit, they stand on all fours, they lie on their sides, they stretch, and they walk or run. All animals are like this. Here's how to work with a shifting subject:

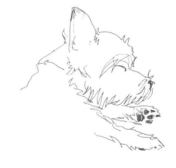

1. Work between multiple drawings: If you aren't able to finish your drawing before your animal strikes a new pose, start a new drawing on that page or the next. As they rotate through their poses, you rotate through your drawings. When they return to a pose you were trying to capture, flip back to that page and complete your drawing.

2. Deepen your observations: Many details don't change from pose to pose: the texture and coloring of fur or feathers, the way animals' bodies are put together, their personality, and character. Each new drawing builds on the study required to make the previous one.

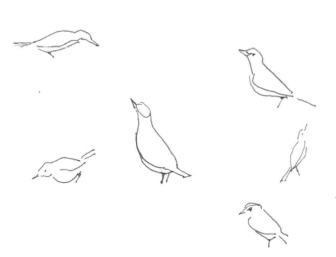

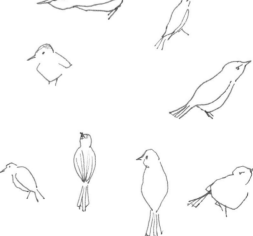

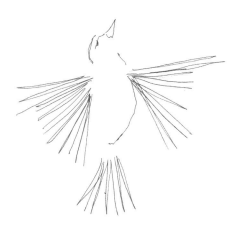

3. Take snapshots in your mind: There is repetition in motion. The legs of a galloping horse repeat the same series of movements in each stride. A squirrel extends its body the same way each time it jumps for a branch. Think of yourself like a sports photographer and snap your shutter each time the movement you want to capture is repeated, isolating the pose.

4. When taking your mental snapshots, notice where the weight is being carried; a gorilla, for example, walks with most of its weight resting on its fists, but a galloping horse can be momentarily airborne. Observe the shape and direction of the movement. The coiled energy of a cat about to pounce is reflected in its rounded body shape and is different from the reaching line of a leaping frog. Pay attention to the quality of the movement: Is it jaunty, stiff, smooth, or silly? Tap into that, and you'll better capture their likeness.

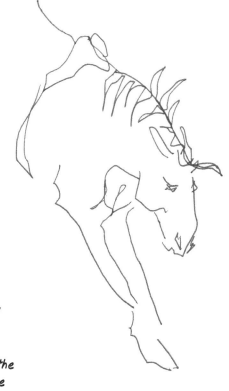

While drawing a flock of pigeons, I noticed that a few key characteristics made my pigeons feel "pigeon-y": The hunch of the shoulder, the small head, long neck, and the pronounced breast were the most suggestive elements for communicating that these were pigeons and not some other bird.

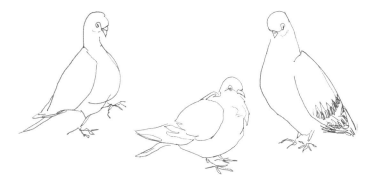

Characteristics Add Character

Physical characteristics define an animal and speak to its essence. Look for and emphasize these traits to make more honest, fun, and storyful drawings.

SUGGESTION
 IS SUFFICIENT

CHAPTER 7

DRAWING FIGURES

If you think of portraits as stories, faces comprise just one detail about people. Their hands, feet, and accessories; the way they sit, stand, or slouch; and the things and places they're interacting with; all of these elements express something about who they are.

We'll get to faces soon enough, but in this chapter, we'll explore different elements we can use to create a person's full portrait. We'll talk about how to draw figures, feet, and hands and how to manage perspective. We'll learn how to tell bigger stories by noticing smaller details. And, we'll see how empathy and the power of suggestion are the secret ingredients to making quick, expressive portraits from head to toe.

Expressing the Human Form

Drawing a person from head to toe can be intimidating. How can you possibly denote every joint and muscle and anatomical detail when you only have a few moments with your subject? I have good news for you—you can't, but moreover, you don't need to!

Even something as simple as these scribbles are enough to communicate a figure. The suggestion of a head, body, and limbs is enough to trick us into seeing a figure because our brains are wired to quickly and subconsciously identify human forms. This is known as *pareidolia*, finding a meaningful image in a random visual pattern. This tendency is why we see animals in clouds, a man in the moon, or an octopus looking for a fight in a simple coat hook.

In addition to instinctively seeking out the human form, our brains are also hardwired to interpret the emotional state of that form. Tapping into these instincts is how you can make a simple collection of lines something that is instantly recognizable as both human and emotional. With this secret superpower in mind, let's draw figures, hands, and feet.

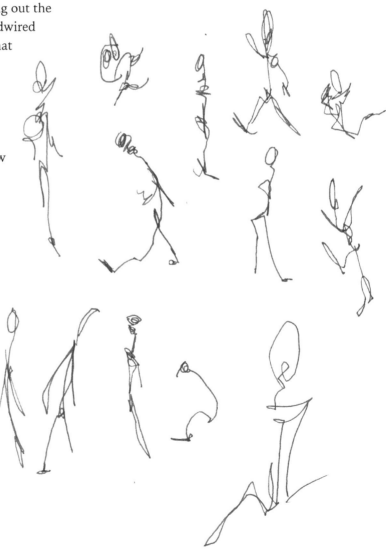

Telling Stories:
How Posture Reveals Emotion

Emotions shape us. When we're sad, we curl into ourselves. When we feel confident, we stand tall. When we are relaxed, we drape into the shape of a chair, or along the length of a bed.

You can experience this yourself by feeling and physically inhabiting these six cardinal emotions: happiness, sadness, fear, disgust, anger, and surprise. Notice what happens to your body when you feel each emotion—how your posture changes and your energy flows. Keep these physical sensations and gestures in mind.

The way a person holds themselves says something about who they are. If you learn to read other people's body language, you'll gain additional insights into their emotional state and understand how to draw their story. Look for the tells: the shy person who turns their toes in to take up minimal space, the confident person who spreads out, the relaxed person asleep on a stranger's shoulder.

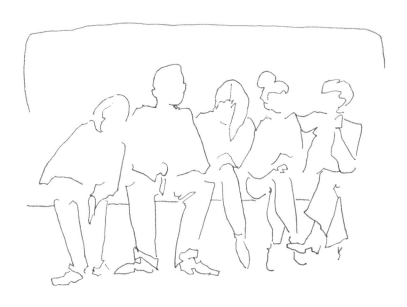

Drawing a Figure Line with Your Own Emotions

When drawing a figure line (see page 86), start with empathy. Empathy is the action of understanding. You attempt to experience and inhabit the emotions of someone else—in this case, your subject. In doing so, you draw what you feel, not just what you see.

Exercises: Body Language

For the following two exercises, you'll create figure drawings by choosing a person whose body language catches your attention and finding and drawing their expressive lines.

EXERCISE 1
Finding and Drawing a Figure Line

1. When drawing figures, look for the most expressive line of the body, the line that connects emotion to action from head to toe. Ballet is one of the best examples of emotion moving through the body. Dancers are pros at using the most expressive line to silently tell stories. The rest of us do this, though not always as dramatically.

2. To create quick figure drawings that capture the essential feeling, energy, movement, or pose, look for the body's most expressive line, and let that line be your guiding force as you draw the elements of the body. Add as much or as little detail to your figure as you want because the expressive line and the shape it creates speak directly to the emotion and anatomy of your subject.

The most expressive line moves from head to toe, connecting both dancers.

The most expressive line runs from the back of his tilted head down the length of his pants. Although this is a rough figure, you get the sense he is confidently interested in something. Would it surprise you to know he's looking at a painting in a museum?

3. Look for someone standing or in motion and find the expressive line. For this woman, who was walking her dog, the line runs from the top of her head, through her arm, down the leash, to the tip of her tiny dog's nose. There is tons of energy in this line.

4. Notice contrasts and reflections. For more dynamic figures, look for postures where the most expressive line is juxtaposed against a contrasting line of energy or is mirrored, or reflected, by a similar one.

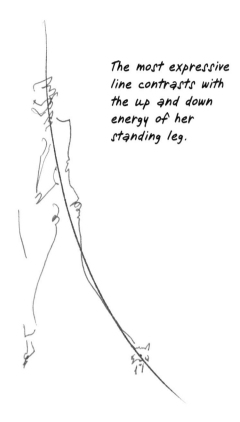

The most expressive line contrasts with the up and down energy of her standing leg.

If you're having trouble finding the most expressive line, look for the following:

Curves

Lines

Serpentines

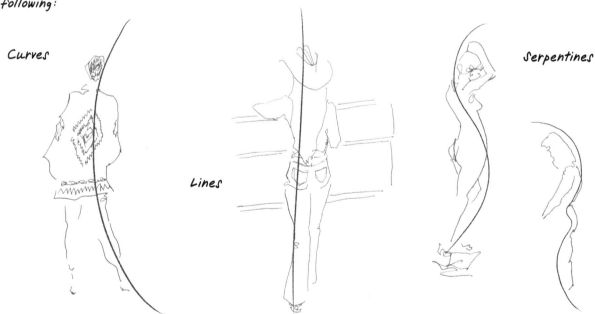

Drawing Figures: The Basics

Use this simple approach to quickly draw figures to populate a scene or transcribe a powerful pose or movement. Remember: You don't need to draw every part of a figure for it to be expressive and complete, only what's important to you or the elements that express what's exciting or interesting.

 You can draw a basic figure in these four steps or experiment with condensing steps one through three, letting the most expressive line lead your hand in one flowing motion.

1. Draw the head. Draw a rough outline of the shape of the hair and face or use the technique for drawing faces (see page 101). Pay attention to the head's tilt or rotation.

 The body follows the head, which is the seat of motivation and inspiration. As such, the most expressive line often originates here. By starting at the head, you can trace this flow of intention through the body as you work your way down.

Step 1

You can also use the head as an impromptu unit of measurement to determine the proportions of the body. See "Managing Scale and Proportion within a Composition" (on page 68) for more information.

2. Draw the shoulders. Notice the angle of the shoulders and the distance between the chin and the shoulder line. The relationship between the shoulder and the head expresses emotion and is often the start of the most expressive line through the body.

3. Working down the length of the body, block in the shapes of the torso, arms, and legs. Use the contour drawing technique (see page 32) and focus on defining the exterior contours. Block in abstract shapes, each one representing a part of the body or clothing. A single line can define the shape of a limb or piece of clothing.

Keep your lines fluid. Tap into tap into the body's sense of movement as you block in the shapes. An overthinking mind will interrupt that flow. Don't be afraid to exaggerate the shapes you see, this can highlight the most expressive line.

Pay attention to points of contact, such as where the weight rests. For a seated figure, notice where the body flattens against the back and seat of a chair or how their feet press against the floor. For standing or striding figures, notice if one leg is carrying most of the weight and how. A few other things to note:

- Use the method for capturing perspective (see pages 96 and 97) for poses with complicated viewpoints.

- For moving figures, capture the action by taking a snapshot (see page 81).

- When a person walks, the opposite arm and leg swing forward together. The receding arm and leg often appear to be hidden behind the body and leading leg (as in the far-left illustration). Taper the shape of the arm and leg to reflect this by tucking them behind the body and front leg or leaving them out to imply a striding movement.

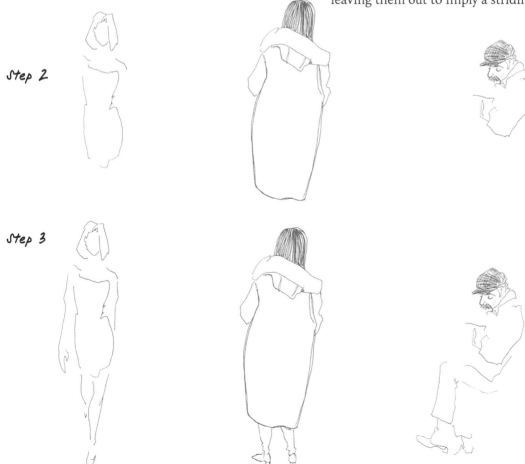

Step 2

Step 3

4. Refine the figure. Add select details to suggest anatomy, emphasize movement or pose, and reinforce the most expressive line.

Wrinkled clothing shows how the body twists, bends, compresses, or stretches and suggests the underlying joints and skeletal structure. If they are visible, draw in points of anatomy such as collarbones, kneecaps, shoulder blades, defined muscles, or fingers and toes. Use flicks and swipes of your pen to suggest these details. Utilize contour drawing (see page 32) and pay attention to the most obvious topographical changes.

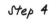

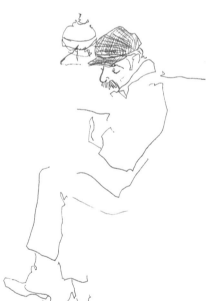

Drawing Expressive Figures

You don't need someone to strike a pose for you to practice reading emotion and seeing the most expressive line.

Take a walk to a café, or museum, or even the grocery store. Make at least 20 figure drawings of the people you see.

Be efficient: Use as few lines as possible, focusing on the most expressive line.

Get weird: You'll make more expressive drawings if you aren't afraid to make some wonky ones.

Get loose: Focus on emotion, gesture, and suggestion over anatomical accuracy.

Be bold: Imagine you're a fancy, over-the-top artist and get your body involved in the process with big, swoopy hand gestures.

To demonstrate the range of ways to quickly express a figure with emotion—even with a single line—I did this exercise on the way to the Metropolitan Museum of Art.

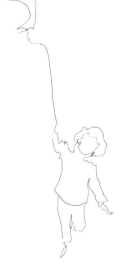

Drawing Hands

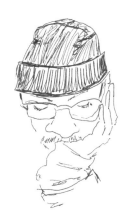

Hands are complicated human machinery. Without staring at a skeleton, it's hard to understand exactly what our digits are up to as we grasp, wave, and wiggle.

Here are a few facts about the general structure of hands that make it easier to understand what you're seeing, ultimately making it easier to draw a hand, no matter what it's doing.

A finger has three joints and three segments, each of which is shorter than the last.

Thumbs follow the same rules as regular fingers, with the first segment attaching at the base and side of the palm. While the fingers have a lot of mobility, the palm doesn't change shape. Open and close your hands to see this in action.

A finger is wider at the bottom than it is at the top.

Remember, suggestion is sufficient.

A hand can be this simple.

It can also be more detailed.

How to Draw Hands

Draped loosely, gripped tightly, or anywhere in between, hands are expressive. Think of their actions as striking a pose. You may have few seconds to capture that pose or have more time if your subject is in a café reading a book. Think of these time constraints as the drawing equivalent of short-form writing or a novelistic approach in the level of details used to express their form.

The following offers a general approach for drawing a hand. You can take more time with this process, adding more details and refined outlines, or you can work quickly, blocking in just the basic shapes.

1. Draw the fingers first, working sequentially and going from finger to finger. Start on one side of the hand and work toward the other. You can work from thumb to pinky or pinky to thumb.

2. Work in the same direction when drawing each finger. If you're working from fingertip to knuckle, work that way for each finger.

3. As you draw, pay attention to the finger's shape and length and the distance between each finger.

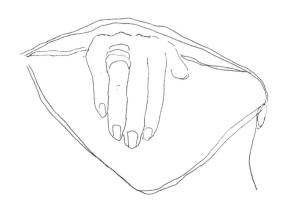

Working from the knuckle down for each finger

Working sequentially from thumb to pinky

Once you're finished drawing the fingers, add the shape of the hand to complete the drawing.

You don't need to draw the entire contour of the back of the hand or palm. Focus on the contours that emphasize the pose, such as the crook of a wrist or the crest of a thumb.

Finish your drawing by adding details like the bumps and wrinkles of the knuckles, nails, tendons, and even jewelry.

Upside down "v's" and little marks represent knuckles

Details: Adding rings, knuckles, and nails

Length: Longer than pinky, shorter than middle finger

Distance: Fingers that touch share a contour line

Think About Shape

For a more detailed drawing, use the contour drawing technique (see page 32). Imagine the pen caressing the edge of each finger and then trace the contour of each detail with your eye and draw that path with your pen.

If you're working quickly, focus on drawing the rough shape of each finger, making sure to obey the rules about a hand's shape (fingers taper, they have three joints, etc.). As you draw the shape of each finger, even if it's approximate, make sure you taper the shape and suggest the bend of the joints. As you follow these rules, the shape you create will communicate the proper anatomy.

Drawing Shoes and Feet
Learning Perspective through Finding Shapes

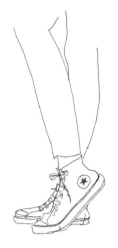

Stilettos or sneakers, oxfords or loafers, snow boots and booties, and every-thing in between—shoes reveal a lot about the places people go and who they are when they arrive.

How people hold their feet also tells you a lot about them: crisscrossed, flat on the ground, shyly tucked, or even playing footsie, feet are expressive. To capture all that, you'll need another kind of perspective.

Perspective gives the impression of a subject's height, width, depth, and position in relation to the things around it when viewed from a particular point.

Feet stick out into space, they twist, turn, and point, and sometimes you can even see the top and bottom at the same time. This can make drawing feet pretty confusing, but it also offers a great opportunity to practice drawing perspective.

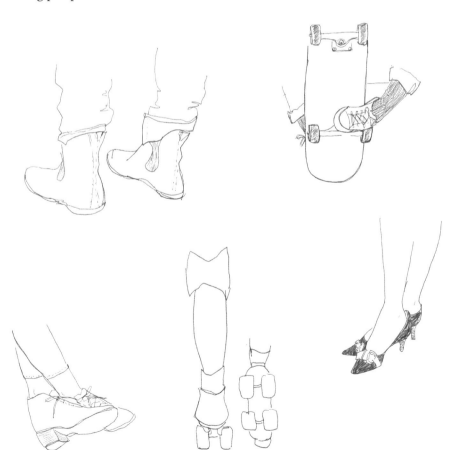

Exercise: Drawing Shoes Using Perspective

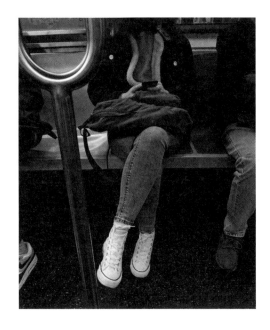

Perspective is shape. Instead of attempting to draw a shoe with a very complicated perspective, draw the collection of unique shapes that, when assembled, happen to look like a shoe. To do this, you must learn to see things differently.

Each shoe on this subway commuter looks different: one is elongated and protrudes towards us, and one is compressed and recedes.

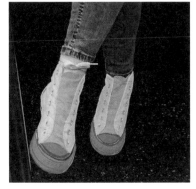

But, here's how I see this pair of sneakers. I break the shoe into composite shapes which together create the sense of perspective we observe.

1. Start with your hook (see page 36). My hook is the woman's legs.

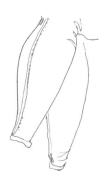

2. Break your subject into unique shapes instead of one singular mass. Stop seeing the object (in this case, a shoe) and instead look for the composite, abstract shapes it's composed of. Because of the way shoes are constructed, the seams are a great guide to see the shapes that create perspective.

Draw the shapes that you visualize, beginning with the most obvious ones. The side of the shoe was clearest to me, so I drew it first.

3. As you add each new shape, you'll draw your subject with perspective built right in. This may look strange and abstract at first, but it will come together in the end—have faith. Draw the second shoe using the same process.

Plan ahead and leave open spaces in the outline of your shapes where other details will intersect or rest on top. I left space to draw laces.

4. Zhuzh it up! Once you've blocked in the basic shapes, tweak them as needed. I drew over some of my original lines to correct them and nudge them into place.

5. Add finer details now, such as stitching, laces, or a pop of color.

What's Your Perspective?

Seeing shapes isn't just for shoes. Whenever you're drawing something that includes perspective, break the scene or subject into shapes first.

A simple street scene is distilled into basic shapes that show a narrowing road and progressively smaller buildings.

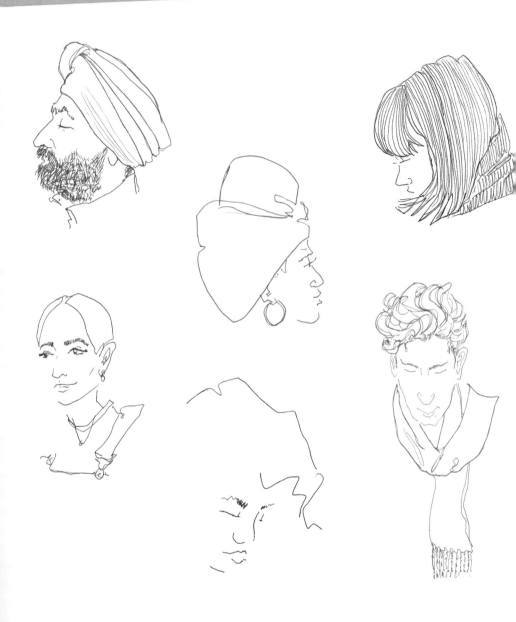

THE SHORTEST DISTANCE BETWEEN
TWO PEOPLE IS A LINE.

CHAPTER 8

DRAWING PORTRAITS

When I first began drawing people on the subway, I made a lot of drawings that looked like my subject and also a lot of drawings that didn't. Though I was frustrated, I didn't reject these portraits for their lack of accuracy. Rather I began to reconsider my criteria for what made a successful portrait. If my drawing didn't look exactly like my subject, but had some elements that illuminated their spirit, I called that portrait a success.

We'll learn to see the face as a series of simple, abstract shapes and lines and talk about how the challenges of drawing strangers in public can contribute to your strength as a portrait artist.

A New Way to Think About Portraits

When it comes to drawing faces, don't think about drawing a face!

I'll show you a method for portraiture that abstracts the features of the face into simple shapes and gestures using as few lines as possible.

As you draw each feature, think about how to describe them: A nose can be aristocratic; strong lines communicate that. An eye can be kind; gentle or flexible lines show that softness. Your portrait reveals a story, so use each line as an investigation of your subject.

We'll map the face without using a grid. Instead we'll travel from feature to feature, each one guiding the placement of the next. Think of yourself as an explorer charting the topography of the face, traveling in a path from top to bottom and from far side to near.

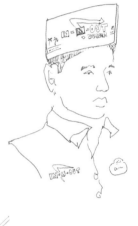

You can adapt this method to suit your own unique style and approach, perhaps drawing features in a different order from what I suggest.

Let time and repetition be your teachers and don't give up if your first hundred portraits don't come out perfectly. If your portrait doesn't look exactly like your subject, do what I do, and say, "Somewhere in the world, someone looks like that—and that's who I drew!"

Finding and Choosing Models

Choose a subject who's sitting close enough to clearly see their face and is in three-quarter profile.

When you have an emotional connection to someone, it can be difficult to see their face as a collection of abstract shapes. I suggest starting with drawing strangers.

I draw whoever interests me. Everyone has a story that's worth telling. If you're lacking inspiration, zoom the room (see page 55).

To practice making candid portraits of strangers, look for places where people spend some sitting or standing still and are close enough to see the details of their faces, such as libraries, cafés, public transportation, airports, malls, parks, and building lobbies.

Exercise: Draw a Face in Three-Quarter Profile

Here you'll draw a three-quarter profile face by focusing on each of these features: forehead and brows; nose; eyes; mouth; chin, jawline, and cheeks; ear; and lastly, hair.

Forehead and Brows

1. Draw the forehead and far eyebrow in one line. Trace the outline of the far side of the forehead and without picking up the pen, draw the shape of the brow, working inward toward the middle of the face. Think about how long or short these features are and consider the shape of the forehead. Does it bow out like an arch to meet the eyebrow or does it slope down like a triangle? Find the simple shape as you make your contour.

2. Drawing the second eyebrow defines the scale and width of the face. Determine its position by observing the relationship between the brows—are they close together or far apart?

Observe the brow's shape: peaked, rounded, or flat? Bushy or sparse? Use a single gesture to draw the eyebrow closest to you—don't pick up the pen once you've begun to draw. You can add individual brow hairs later.

The brow closer to you will be a little longer than the brow farther from you. Features on the far side of the face are always a little compressed because of the effects of foreshortening.

Nose

1. Notice the shape of the nose. Is it hooked, angular, straight, or sloped? Draw the nose in one line. Place your pen at the bridge of the nose (which begins at the innermost point of the far brow) and trace the topography of the nose, working down around the tip, the inside edge of the nostril, and continuing around to the outer edge of the nostril.

2. Depending on the nostril's size and your perspective, you may need to draw some of the far nostril arch or interior. A little linework goes a long way to suggest these details. Start with small marks and add more if you need.

Eyes

The eyes convey a lot about the subject, but you don't need a lot of linework to capture that essence. Communicate the basic shape of the eye in two lines: one representing the upper eyelid fold and the other representing the upper lash line.

1. Continuing to work from the far side of the face to the near side, draw the far eye. Using a single motion and working inward toward the nose, draw the shape of the upper eyelid fold. Next draw the upper lash line. If you're overthinking this feature, abstract the eye into basic shapes like semicircles, almonds, or half ovals.

Draw the near eye next. Start close to the nose and work to the outside. The closer eye is drawn slightly larger to show perspective. Match up the inner corners of the eyes to keep them on the same plane.

2. Add the iris. The iris is usually slightly covered by the lid, so draw it as a semicircle below the lash line. You can connect both ends of the semicircle to the lash line or leave the semicircle unattached on one end, which brings more life to the eye.

Partly color in the semicircle, leaving some white space in the middle. Experiment with how much you color; leaving some white space off-center captures a glint in the eye. Next, add details such as eyelashes or eyeliner.

3. The line of the bottom eyelid can add a lot of character. Don't feel the need to trace the whole bottom lid line, which can make the subject look overly tired or old. I added a bit of the outer corner of the bottom lid to give some smile to the eye.

4. If your subject has hooded eyes (where the eyelid is still visible when the eye is open), or their eyes are closed, you can still draw the eye in just two lines.

Mouth

1. Draw the top lip. Position this on the face by using the bottom of the nose as a reference to judge the distance between the nose and mouth. Observe the shape of the top lip's outer contour and draw it, keeping in mind the basic shapes of the lips, such as triangular points, rounded cupid's bow arcs, or more of a straight line.

2. Draw the outer contour of the bottom lip, which conveys its fullness. A longer, more rounded line suggests a fuller, more protruding bottom lip. Don't connect the lines of the top and bottom lip, as this can look cartoonish.

A slight curl at the outer edge of the upper lip can turn a passive expression into a smiling or friendly one. Experiment to find more varied expressions.

If someone has a pronounced philtrum (the little groove that runs between the nose and top lip), draw that as well.

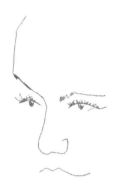

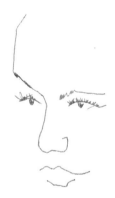

Some people's lips are more defined by the inside contour of the upper lip. In this case, consider adding a small contour line to suggest that detail.

Chin, Jawline, and Cheeks

Just two or three lines can suggest the chin, jawline, and cheeks and enclose the shape of the face. You can draw the chin and jaw in a single line to give the impression of a firm jaw. Or draw the chin and jaw in two lines to express subtle details in that part of the face, such as a pronounced chin or a softer jawline.

1. Position the chin relative to its distance from the line of the bottom lip. Draw the chin, working from far side to near, keeping in mind the basic shape: square and angular or soft and round? You can extend the chin line to include a bit of the jawline as well.

2. Draw the jaw with a line that picks up a short distance from the chin. In this case, I wanted to suggest the edge of the jaw, so I drew a slightly curved line to show where the jaw turns toward the ear.

Experiment with making this line short, long, or even omitting it. These variations can suggest a soft face; a leaner, more chiseled face; or a determined expression.

3. Now draw the cheekbones. For the cheekbone on the far side of the face, a short, curved line can indicate cherubic cheeks, while an angled line suggests high cheekbones.

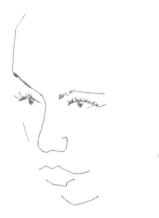

Ear

1. Map the placement of the ear by noting the relationship of the top of the ear to the brow line: is it lower, higher, or in line? Determine the size of the ear by noting where the earlobe attaches. Does it align with the bottom of the nose or perhaps the corner of the mouth?

Draw the ear, connecting the top and bottom points by tracing its outer contour, starting from the top.

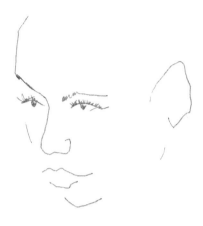

2. Draw the ear's inner folds. I like to have fun with these. A few squiggles is enough to suggest this detail.

Hair

1. Using a single line, trace the edge of the hairline, using the eyebrows as a reference to place the line. The hairline defines the forehead size and suggests the curve of the head. I drew just enough to suggest the peak of her forehead and her temple.

2. Add volume and shape by tracing the outline of the hair. I added a few lines to suggest the hair swirling into a spiraled bun.

Final Details

Look at your drawing and compare it to your subject. Now's the time to add facial hair, piercings, dimples, smile lines, and other distinguishing features.

You can also add the neck line and the details of the upper bust and chest. Be mindful of where you place the outline of the neck; too far forward and you'll create a thick neck and short chin, and too far back and your subject will look like a bobblehead.

Drawing Eyeglasses

Glasses add personality and frame the eyes, but they can be confusing to draw. Whether you're drawing glasses straight on or in profile, block in the shape of the frames before drawing the brows, nose, and eyes. This sets the scale and makes it appear that the glasses are resting on the face. As you draw the brows, eyes, and nose behind the glasses, any details obscured by the frames are naturally left out.

When drawing glasses on someone in profile (full or three-quarter), slightly compress the far-side lens so it appears farther away.

Draw the top line of the glasses first.

Draw the shape of the frame. Be specific and take your time to capture the shape and style of the frame.

Add the eyes and brows behind the frame.

Drawing Portraits in Profile

Think of a profile portrait as tracing the topography of just one plane of the face, in the same way you would create a silhouette of your subject. The process is similar to drawing a three-quarter profile, but here are a few tips:

When drawing the eyes, the iris is semi oval, not a semicircle. You can also use a simple dot to suggest the iris.

When drawing someone in full profile, block in the shape of the hair first. The outline of the hair then becomes a reference for where to place the brows.

Try to imagine the skull underneath the hair and note that it curves like a question mark from the top of head to the base of the skull where it meets the neck.

Draw the silhouette of the lips showing how they protrude from the face or add extra detail by drawing the inner contours of the lips.

You can also choose not to enclose the head at all.

Drawing Portraits Straight On

Drawing straight-on portraits can be tricky because the topography of the features, so clearly revealed in profile, is less clear head on. To compensate for this, pay attention to the way light and shadow suggest the features' depth and definition.

Light hitting your subject creates more shadow on one side of the face. To express the depth and shape of protruding or receding features (the nose, brow ridge, dimples, chiseled cheeks, under-eye bags, etc.), observe how these shadows fall and draw their contour on the more heavily shadowed side. If someone has strongly defined features, make symmetrical marks on both sides of the face.

Use the same techniques and approach for a three-quarter profile, with the following tweaks:

1. Draw some of the hairline first as a reference for where to place the brows.

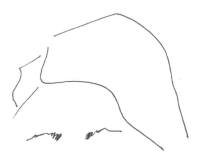

2. Set the nose by making a mark where the bridge meets the brow. If the bridge of the nose is angular and strong, draw a longer line. Draw the outer ridges of the nostrils, establishing the length and width of the nose.

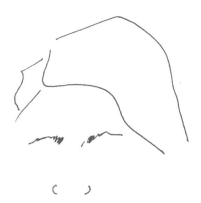

3. Draw the tip of the nose. Remember the basic shapes: Is the tip of the nose pointy like a triangle, or wide and curvy?

4. To create more definition, add a contour line to define the shape of the bridge or the sides of the nose. A wide nose may not need any extra definition, but one that's angular or sharp may need lines on either side of the bridge.

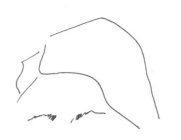

When adding deep worry lines, brow furrows, dimples, and other expressive lines, use symmetrical marks. Otherwise, suggest them with a single mark on the shadowed side of the face.

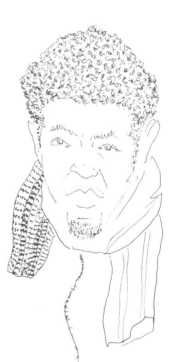

To draw the ear, you only need to suggest the upper curve of the ear and earlobe. You also may not need to draw both ears. Unless the person is truly facing you straight-on, one ear will be more visible than the other.

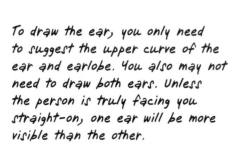

How to Be Stealthy

When I started drawing on the subway, I was not stealthy at all. Being observed changed people's behavior, making it difficult to create truly candid portraits. So I learned how to go unnoticed while noticing others.

Embrace Your Inner Spy

Here are my tips for embracing your inner spy:

- Don't stare for too long and don't look someone directly in the eyes.

- Practice observing your subject using a soft-focus gaze; relax your eyes and take in a wide-lens view of the world. Observing someone in your peripheral vision allows you to sketch them without looking straight at them.

- Someone engaged in a task such as reading a book or talking to a friend is less likely to notice you. Other great options include sleeping subjects or people who are zoning out.

- Hold your sketchbook so that your subject can't see what you're drawing.

- Stand out of the way or off to the side of your subject, so you're out of their direct line of sight.

- If someone catches you looking at them, pretend as though you're looking past them. I imagine I'm a spy, and I practice acting naturally when I draw in public. The more normal you act, the less people notice you.

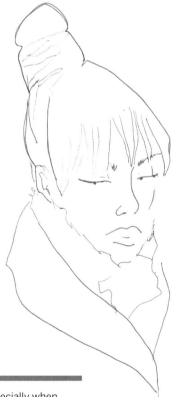

Be respectful, especially when you're drawing strangers in public. This is important no matter whom you are drawing, but especially for people whose appearance might make them self-conscious.

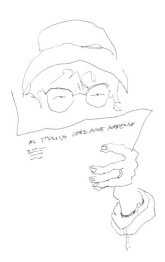

What If Your Cover Is Blown?

If someone is curious or unhappy about what you're doing, simply smile and be friendly. Offer to show them your sketch and let them know they inspired you to draw them because they are inspiring. This is usually enough to turn anyone's concern into a nice moment of connection, especially once they see what you're doing. That said, use common sense and don't sketch people who seem dangerous or clearly don't want to be drawn. If you're drawing someone official like a police officer or soldier, ask permission first.

Treat your subjects with curiosity, rather than being judgmental or making fun. This approach reflects back on you: Appreciating someone else's unique characteristics makes you appreciate how unique you are. Remember: You are a work of art, and you're sitting next to a masterpiece.

Memorizing Details

In my quest to become a stealthy sketcher, I was inspired by a real-life spy who wrote about memorizing faces to record important details when taking photos was too dangerous. I challenged myself to memorize my subjects' faces and eventually, in just a few glances, I could re-create an entire face. This skill is especially useful for avoiding unintentional staring contests, and for finishing portraits when a subject leaves while you're still working.

Since I didn't go to spy school, I developed my own technique for drawing a face from memory:

- Zero in on your target. Get the overall impression of the face and personality. Note any stand-out features or accessories like a big collar or an eccentric scarf.

- Instead of staring, use your memory as a reference: Take a mental snapshot for each section and then draw it.

- Memorize and draw the face in three sections and three glances, drawing after each glance. First glance, focus on the forehead and brows. Second glance, focus on the eyes and nose. Third glance, focus on the mouth, chin, and jaw.

- Take a final glance to cross-check your subject against your drawing.

- It's okay if you look more than three or four times; the point is to become better at quickly absorbing a person's features and essence.

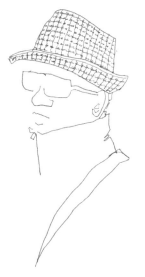

You can also memorize how to draw specific details like houndstooth, the way fabric wrinkles, curly hair, or even postures. Each time you observe something, store that information in your mental file. Should you need to, you can fill in details by pulling from this more general store of images to supplement your drawing.

Practicing the Art of Letting Go

Once you start drawing out in the world, you'll notice your models do strange things, like leave halfway through your drawing, as if they had no idea they were part of your impromptu art studio. Here are some tips for finishing a portrait from memory:

- Set a timer for three minutes and begin your portrait. Once the timer goes off, put the pen down and face away from your subject. Finish drawing the portrait by memory. No sneaking extra peeks—if you can't remember a detail, make it up.

- For a real challenge, repeat the exercise above and finish your drawing the next day. You'll be surprised at how many details you recall.

This page will self-destruct after you've completed the exercises herein.

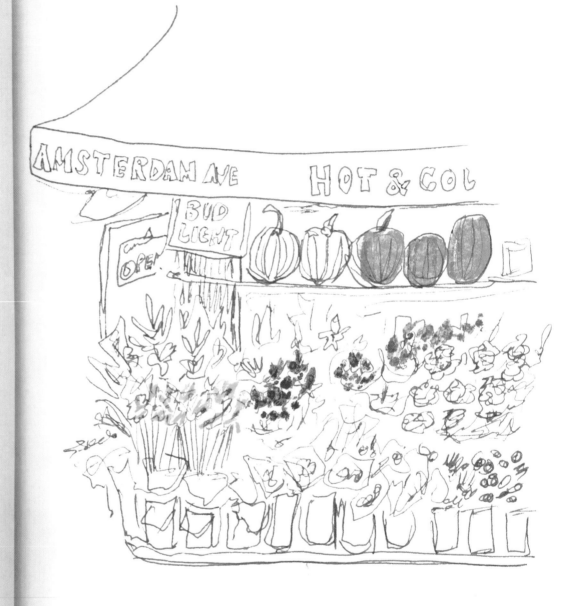

WE ARE <u>ALWAYS</u> ON THE WAY

TYING IT ALL TOGETHER

I often refer to my sketchbooks as my notebooks because they're filled with more than just illustrations; they also contain notes on daily life. Your drawings will become memories, permanent companions, and a record of where you've been and what you've seen.

This chapter is about the finishing touches that make our on-the-way stories come to life, such as adding color and titles and knowing when to stop. We'll learn how to use the supplies and tools you can easily take with you to add splashes of color to your work. We'll talk about the importance of a title and why sharing your art is a scary—but awesome—part of the creative process. And, as we turn the final pages together, we'll discuss the less tangible things you can take with you as you continue your creative journey.

Using Color Effectively

I'm a firm believer that it's possible to capture an entire world with just a few strokes of a humble office pen. But a pop of color can easily add to the story.

Color provides focus; it pulls our attention into a scene and acts like a spotlight by adding visual weight. It creates mood; a simple swipe of bright red lipstick or an atmospheric wash of neon city lights proves that color is emotional. And it offers context; like a set backdrop, color conveys a deeper sense of place or time.

For this country scene, drawn from the window of a moving car on a family vacation, I added color when I got home. Warm yellow fields and long shadows add a sense of time—fall, late afternoon—to this illustration.

If you don't have paints with you, add color later. Use your memorization spy skills (see page 113) to remember the colors or jot down notes to remind you. Adding color to your memories is a lovely way to bookend an adventure or just a regular day.

Portable Supplies

When considering what supplies to take with you, consider portability and setup. If you need a table or require lots of space, it's not ideal. Also, stay away from supplies that make a mess or require stable environments.

Colored Pencils

Colored pencils are easy to use and carry. Vary the richness of a color by adjusting the pressure, and layer and blend to make new colors.

You can also create linework with colored pencils.

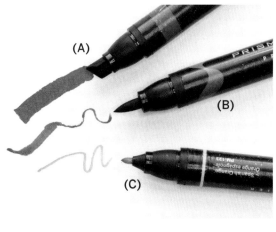

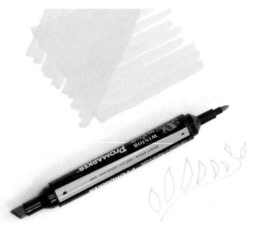

Add a white gel pen to your color kit. It marks on top of most non-waxy media and is a great tool to add highlights or create text for signs.

Markers

Markers are another easy, super portable way to add color. Here are a few tips:

- Layer colors from lightest to darkest and keep in mind that the more you pass over an area with a marker, the deeper the color will become—good to know when creating depth with a single color.

- When filling in with color, use small circles or short flicks for more blended edges.

Pay attention to the variety of tip styles and the advantages they offer:

- **Chisel tip** (A): This is a broad tip that can lay down big patches of color.

- **Brush tip** (B): This tip is flexible and allows for variety in line work.

- **Fine-point tip** (C): This tip is good for small details.

Watercolor and Gouache

Watercolor and gouache are both water-soluble paints that are portable, easy to use, and clean up easily. These are art forms unto themselves and can take years to master. Since we're using paint to augment our illustrations, some simple techniques can add beautiful spots of color to your work. Here are a few tips that work for both:

Load a brush with a lot of paint and use it almost like a marker to add powerful pops of color or even create line work.

Use the brush tip as a stamp to make repeating shapes like flowers or leaves (for more on the stamping technique, see page 73).

A wash of color makes the sunset on this minimal sketch of a New Mexico road

The more water you mix into the paint, the more dilute the color will be. Here I used the same deep blue paint to make a light, transparent blue color and a deep rich blue just by adding more and less water, respectively.

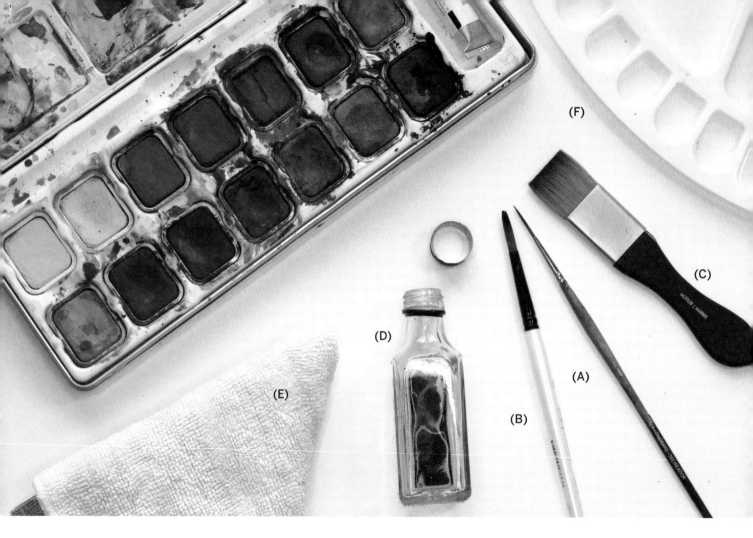

Putting Together a Basic Watercolor or Gouache Kit

A Basic watercolor or gouache kit should contain the following:

BRUSHES

- **Fine** (A): Use this brush to add tiny details with pinpoint precision or to make line work.

- **Round** (B): This brush is a workhorse. Use the tapered point for detail work or the whole brush to paint wide swaths of colors.

- **Flat** (C): A wide, flat brush is perfect for adding big color washes.

PORTABLE WATER CONTAINER (D)

Use a tiny bottle; a light, collapsible water pot; or a brush with a built-in water reservoir.

SMALL RAG (E)

Use this for cleaning brushes or lifting excess paint from the paper. You can also use the back or your hand to wipe extra paint from your brush. (More than once I have used my sock as an impromptu brush cleaner.)

PALETTE (F)

If your paints don't already have a small mixing palette, bring a small separate palette to mix colors.

Watercolor paint kits, such as the fan pan on page 4, are a great way to bring watercolors with you, since they're tidy and compact.

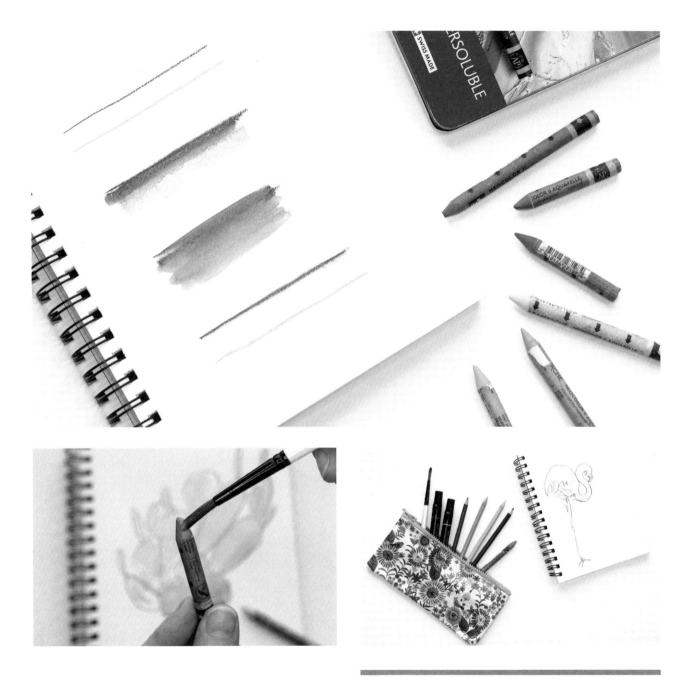

Water-Soluble Wax Crayons

This versatile medium can be used like a crayon, blended like a pastel, and when wet, act like watercolor.

Use a wet paintbrush over select areas to soften edges or melt lines into sweeps of color. Or, use them as portable paint sticks by loading color off the pastel with a wet brush.

Keep a small bag packed with a few favorite coloring tools. I bring my sketchbook and pen with me wherever I go, but if I have extra room or anticipate going somewhere exciting, I'll drop my color kit into my bag.

A benefit of keeping a few coloring tools in your kit is the challenge of a limited palette. If you only have a few colors to work with, what details will you focus on? Will you look for inspiration with a different perspective?

Knowing When to Stop

You never know when your muse will leave or a scene will change. The unpredictability of drawing on the way inspired me to reconsider when a work was truly done. If you're wondering if it's time to turn the page, ask yourself two questions:

Does this drawing make me feel something?

- Did I capture the essence of my scene or my subject?

- Do I feel the way I felt when I was inspired to draw this?

- Does it make me feel happy? Just being satisfied with your work is enough.

Did I include the relevant details of my story? Only you know the answer to this question. In this book, you've seen complete stories told through a portrait, a pair of shoes, or even a single line.

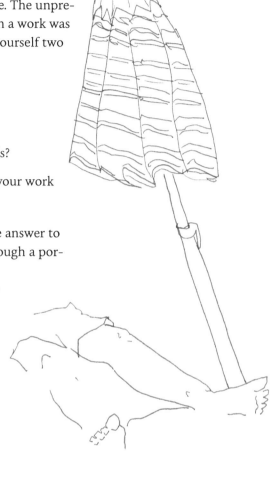

Exercise

Here's an exercise to explore the various stages of being done. Set a timer for 3 minutes. When it goes off, stop, look at your drawing, and ask yourself the following questions:

- In this unfinished state, is there some part of the story that is better expressed with less?

- If you could only add one more detail, what would it be?

You can always add more, but when you're working in pen, paints, and markers, you can't take anything out.

Draw Like You're Cooking

Excellent cooking advice was passed down from my great-grandmother to my mother and then to me: When adding salt to a dish, add a little bit at first and then taste. You can always add more, but you can't take it out. When drawing, as you add final details, keep your story front and center and consider how much you really need to complete your illustration.

Titling Your Work

A title is a sign of respect. When you title your drawing, even if it's something you dashed off in a few minutes, it elevates the work and honors your efforts. A title can also be commentary, encouraging the viewer to see the story as you saw it, or focus on particular aspects of it.

A title can also:
. . . be a secret between you and your work . . .

Title:
"As if in Prayer"

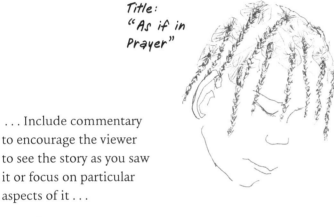

. . . Include commentary to encourage the viewer to see the story as you saw it or focus on particular aspects of it . . .

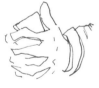

Title: "May I Have Your Attention, Please"

. . . Answer questions, add context, or add a punchline to the visual story.

Title: "More Wine, Madame?"

Get creative with your titles and consider them a part of your creative process.

A Title Can Inspire

I don't often get to hear what happens to my portraits once I've given them away, but this story found me and reminds me why our job as visual storytellers is so important.

After a particularly bad day, I found myself deep in thought, slightly teary and giving myself an internal pep talk while riding the Metro in NYC.

I glanced to my right to see a lady sketching. As my stop approached, the lady leaned over and said "Your hat is awesome. You caught my eye as you got on the train, I hope you don't mind but I've been sitting here sketching you."

What the lady didn't realize was I had been sitting there mentally beating myself up and feeling pretty down. Her gesture of handing me this piece of paper and saying she wanted to sketch me was just the confidence booster I needed. The title she gave it, unknowingly, was also pretty serendipitous: "Weather the Storm." It was one of those precious moments in life when the smallest gestures restore your faith in humanity again.

— Sarah Parmenter, London, England

FINAL THOUGHTS

Share your drawings with the world. And, if you feel so moved, give your drawings away to the person you've drawn or to someone who shared the experience with you. Sharing multiplies the joy of creating. When you share your drawings, the three stories contained within them (see page 25) collide in real life, and you'll see the power of what you have made: a version of the world that has the ability to delight, move, and inspire.

When I began sharing my daily drawings on social media, I had to come up with a name my account. For many years, I understood the name I chose, Drawn on the Way, in the literal sense: I was drawing on my commute, recording small, seemingly invisible moments in transit. But by noticing the little moments that happen along the way, you also begin living in them. And that makes the literal and metaphorical journey much more interesting.

Since I began drawing daily, there has only been one moment where I lapsed, when my brother passed away. My world stopped and felt like it would never begin again. But one day, the spark showed up, asking me to pick up my pen and create my world again. The simple act of drawing my own shoes, the view from where I sat, brought a very important part of me back to life. I have followed that spark wherever it leads me. And now, I pass it on to you.

This is the final chapter of our story together, but it's not the end of your journey.

Whatever you do with your new creative practice, remember that its highest purpose is to bring you joy.

Keep your creative process free of judgment and your drawings will always add to the view, bringing love, interest, order, stories, empathy, curiosity, and yes, art to your world. It's a remarkable transformation that can be done (as we've proven) in as little as one minute, with just a simple pen and paper.

We are always in transit. On the way is not a place, it's an ever-shifting point from which we begin again and again. There's always another page to turn, new chapters to write, and sketchbooks to fill. This is your life, and I hope you enjoy the view.

RESOURCES

uni-ball pens: uniballco.com. My favorite pen, used for every drawing in this book, is the Roller: uniballco.com/roller

Canson sketchbooks and paper: en.canson.com

Caran D'Ache Neocolor II water-soluble wax oil pastels: carandache.com/us/en/neocolor-ii-watersoluble-s-1095.htm

Winsor & Newton: For more information on painting with gouache and watercolor: winsornewton.com/na

Artistic inspiration: The Metropolitan Museum of Art provides endless inspiration and examples of how artists share their point of view. Tour the museum and its collection of 5,000 years of art from around the world: metmuseum.org

ACKNOWLEDGMENTS

Thank you . . .

To my parents, for your unconditional support and for showing me, each in your own way, how to find the extraordinary in the everyday. To Hadley, for your endless patience, love, and smarts, without which this book wouldn't exist. To Panda, for being the Tina to my Amy. To Hannah, for being with me always. To Dr. Lu, for guiding me. To Charles Krasnow and to Heather Glidden, for keeping me together. To Matt, for showing me the way then, now, and always.

To Jeannine Stein, for giving me the opportunity to share my passion, and for having confidence that I could. To John Donohue, for your generous help, and for connecting me to my amazing agent, Laura Lee Mattingly. To Brittany Hennessy for giving me my first real gig.

To everyone who has followed along with @drawnontheway. You inspire me to keep sharing and drawing.

And, finally, thank you to the city and people of New York for being a source of endless inspiration, and to the F train for always running late, and teaching me how to enjoy the ride.

ABOUT THE AUTHOR

A self-taught live sketch artist and illustrator, Sarah Nisbett loves to draw the people, places, and things she encounters "on the way." Her Drawn On The Way project is dedicated to helping people find the extraordinary in the everyday and to see themselves and others as works of art.

Originally from Ann Arbor, Michigan, she moved to New York City to pursue music. After a successful career as a professional opera singer, it was literally on the way to her next career in advertising that she discovered a passion for drawing on her daily commute. This daily detour led her to a full-time career drawing and writing. Both of which she likes doing. A lot.

In her spare time, you can find Sarah outside riding horses (a lifelong passion), surfing, or working on her archery skills. If you're looking for her inside, you might find her doing musical improv comedy, reading history books in search of the universal theory of everything, or visiting the Metropolitan Museum of Art. When she's not doing any of those things, she's probably thinking about how much she loves dogs or what to cook for dinner.

INDEX